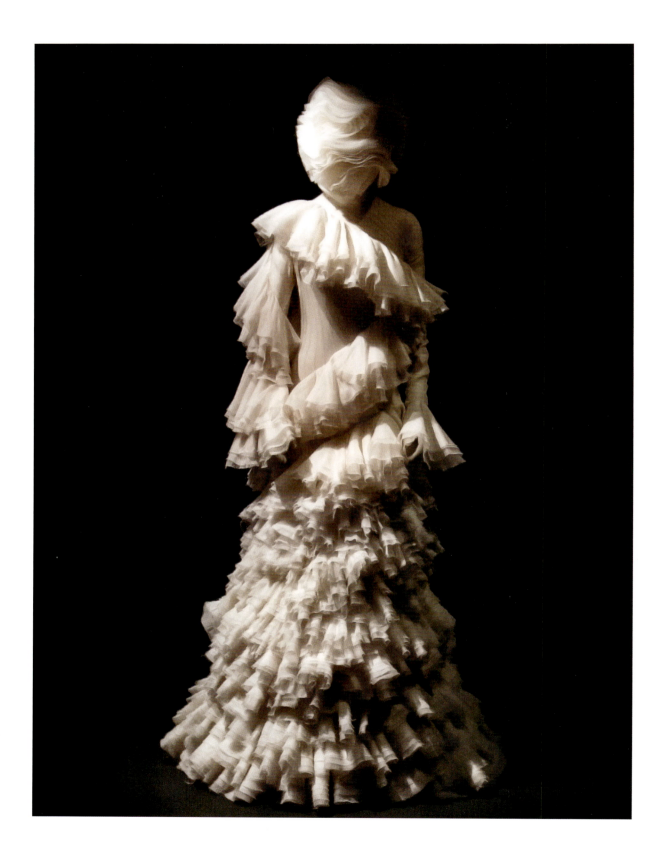

THE FASHION ICONS

McQUEEN

Written by
Michael O'Neill

sona
BOOKS

© Danann Media Publishing Ltd 2023

First published in the UK by Sona Books, an imprint of Danann Media Publishing Limited

Not to be reproduced without permission.

WARNING: For private domestic use only, any unauthorised copying, hiring, lending or public performance of this book is illegal.

This book was previously published under the title Alexander McQueen - Redefining Beauty.

CAT NO. SON0573

Written by Michael A. O'Neill
Additional text by Gail Picken
Book layout & design Darren Grice at Ctrl-d
Proof reader: Juliette O'Neill

Photography courtesy of

Getty images
Pierre Verdy/AFP/Getty Images
Paul Vicente/AFP/Getty Images
Dave Benett/Getty Images
Francois Guillot/AFP/Getty Images
Catherine McGann/Getty Images
Andrew Winning/AFP/Getty Images
Steve Eichner/Getty Images
Alexis Duclos/Gamma-Rapho via Getty Images
Sinead Lynch/AFP/Getty Images
Hugo Philpott/AFP/Getty Images
Martin Hayhow/AFP/Getty Images
Victor Virgile/Gamma-Rapho via Getty Images
Nicolas Asfouri/AFP/Getty Images

Jean-Pierre Muller/AFP/Getty Images
Pool Bassignac/BUU/Gamma-Rapho via Getty Images
Chris Jackson/Getty Images
Xavier Rossi/Gamma-Rapho via Getty Images
Andy Paradise / Stringer
Filippo Monteforte/AFP/Getty Images
Chad Buchanan/Getty Images
Giuseppe Cacace/AFP/Getty Images
Damien Meyer/AFP/Getty Images
Chris Moore/Catwalking/Getty Images
Maria Valentino/FTWP
Victor Boyko/Getty Images
Andrew H. Walker/Getty Images
Carl De Souza/AFP/Getty Images

Photographs: All copyrights and trademarks are recognised and respected

Every effort has been made to acknowledge correctly and contact the source and/or copyright holder of each picture and Sona Books apologises for any unintentional errors or omissions, which will be corrected in future editions of the book.

All rights reserved. No part of this title may be reproduced or transmitted in any material form (including photocopying or storing it in any medium by electronic means and whether or not transiently or incidentally to some other use of this publication) without the written permission of the copyright owner, except in accordance with the provisions of the Copyright, Designs and Patents Act 1988. Applications for the copyright owner's written permission should be addressed to the publisher.

Made in EU.

ISBN: 978-1-915343-32-1

This book was previously published as Alexander McQueen Redefining Beauty.

CONTENTS

THE ALEXANDER MCQUEEN PHENOMENON 8

THE EARLY YEARS 1969-1985 12

FROM SAVILLE ROW TO MILAN 1985-1991 14

LONDON BECKONS 1991 - 1996 18

THE GIVENCHY YEARS 1996-2001 32

UNBOUNDED FAME 2001-2006 56

GLAMOUR AND PAIN 2006-2010 92

THE LEGACY 134

THE RUNWAY COLLECTIONS 136

ALEXANDER MCQUEEN QUOTES 138

WHAT OTHERS THOUGHT 140

THE FASHION ICONS McQUEEN

THE ALEXANDER McQUEEN PHENOMENON

"It's all been done before . . . it is how you do it"

Lee Alexander McQueen was a child of his age, one in a long line of talented, tormented celebrities that do not live out their three score years and ten. On a personal level, he was a contradiction even to himself. He was constantly seeking release from his personal demons and never finding it, and this conflict manifested itself in his designs, igniting his fantasy. When unencumbered by a commercial restraining order, his creations were restless and surrealistically exotic, the soaring flights of a searching, yearning imagination. The world needs fantasy, there is enough reality, he said, yet his harsh view of reality and the pain in the world filtered into his fantasy and therefore into his work alongside his vulnerability and passion.

On a mundane level, McQueen was the worthy successor to the English fashion designer Charles Frederick Worth, who lived from the 13th October 1825 to the 10th of March 1895. He was the first Englishman of whom it could be said that he broke through the boundaries of fashion design, as McQueen was to do 150 years later. Worth's clothes were produced in Paris, and he is widely thought of as the father of haute couture.

McQueen polarised opinion, and the word 'genius' was often used to describe him. This was not a universally held opinion in the great halls of fashion. On both sides of the divide, however, what was in no doubt was that his was

THE ALEXANDER McQUEEN PHENOMENON

a bounding creativity that was fuelled by a vivid, driven mind and executed by a highly skilled hand. He saw a piece of clothing as an objet d'art, as a way of transmitting concepts and ideas, not simply as clothing for the body. He succeeded, with almost frantic energy, in showing us where that thought could lead, taking the observer on a fantastical journey. McQueen thrust clothing beyond its usual inhibitions, beyond the limitations others had imposed upon it by imagination, pattern and dimension and in doing so, found himself leaving the arena of haute couture and entering the world of theatrical expansiveness, before then brilliantly combining the two.

McQueen's oeuvre was intensely autobiographical and therefore personal; as a consequence it was unique. His work orbited around recurring themes; one of these was his ancestral Scottish history, and an interest in history in general and how it could be used to inform modern clothing forms and fabrics. He considered himself a romantic – on Valentine's Day he would send 500 red roses to his boyfriend at the time – and romanticism pierced many of his shows in all of its gentle and harsh manifestations. This he had in common with the old masters, and he often drew inspiration from them and the eras in which they worked.

McQueen's creativity did not shrink back from expressing his emotions, either, and we saw that these were often in turmoil, and always reflecting his own – never truly satisfied – perception of romantic idealism which was marbled through with menace. He has been called 'Byronic' because of the undercurrent of lonely melancholy pervading his romanticism, and for the rebelliousness in his character, his search for the dramatic gesture; but he was a quintessential baroque man of the first order, too, displaced and dropped into the 21st century and consequently disoriented. He was the master of exuberance, richness and sumptuousness, a virtuoso of intricate and ornate workmanship, a style catalyst.

As with many artistic spirits, the exotic, the strange, the unusual attracted him with a magnetic draw and he incorporated foreign clothing styles into most of his work criss-crossing the centuries to do so. These styles came from anywhere that caught his attention; Japan especially, which figured strongly in many collections, but also China, Africa or India and their influences flitted in and out of his work like butterflies.

Nature was a theme of pivotal importance to him; he revisited it often and it provided him with a fountain of ideas that never dried up. His respect for it was obvious; for example, he allowed nature to have the last word in his final show, 'Plato's Atlantis', where it had forced man to adapt to its demands instead of vice versa. Within the context of nature, birds, flying through the darker levels of humanity, figured strongly in his narratives, as did an exploration of the nature of female

THE FASHION ICONS | McQUEEN

sexual power, unknown to him on a personal level, as he admitted, and therefore all the more mysterious. As indeed, were the machinations of love and sexuality; the person he most wanted to meet in life was the Marquis de Sade, the name of a man commonly associated with his sexual exploits who, McQueen said, made him feel as though his own life were banal. *"I gather some influence from the Marquis de Sade because I actually think of him as a great philosopher and a man of his time"*, said McQueen of his idol.

Despite his love of the past, McQueen was a trail blazer in his own world. The art/violence/shock connection had already been fully explored by performance artists before McQueen arrived on the scene and he had very probably observed or experienced it first hand in London. To the moneyed, genteel world of high fashion, however, it was a startling new concept. In the 1990s, McQueen was the first to fearlessly transgress the art/violence/shock barriers. He was a man of his time. He also lived in an era of technological revolution and made use of the cross-over influences from the contemporary art world. With his use of computerised technology to create random patterns, he allied himself with the idea of machine art and the questions that posed. He used digital printing to create highly original pieces. Even his innovative, glossy signature shows that helped propel him to the top of his profession were in keeping with the sun-king splashing of wealth that became prevalent in the egotistical society of the 21st century. They were said to have cost an estimated one million dollars per ten minutes.

Although seen by many as an avant-garde master designer, his true talent was founded on an unsurpassable ability to cut, construct and tailor his work.

As McQueen says of fashion: *"It's all been done before . . . it is how you do it."*

Perhaps the saddest pictures now are of McQueen wearing skeleton designs, or his image on the cover of "Savage Beauty" which morphs McQueen into a skull. This image of death was so at odds with the flamboyant brilliance of his achievements that it seems inappropriate for this one-dimensional image of his character, or indeed the clumsy 'bumster', to be the legacy impressions of the man who, literally on occasion, harnessed the ennobling creativity of his fellow humans and the world around him to hypnotise, enrich and bring a sense of wonder and magic into the smoke and mirrors world of fashion.

THE FASHION ICONS — McQUEEN

THE EARLY YEARS 1969-1985

"I came to terms with not fitting in a long time ago. I never really fitted in. I don't want to fit in. And now people are buying into that."

In 1953, Ronald McQueen, a London taxi driver, married his girlfriend Joyce in Stepney, London. Joyce Barbara McQueen was 18 years old. Significantly for her youngest son's future, Joyce was also an amateur genealogist as well as a social sciences teacher; she traced her family's roots as far back as the Huguenots who sought sanctuary from religious persecution in mainland Europe, settling in East London's Whitechapel and Spitalfields districts 250 years ago. In her research into the McQueen family line, she had also discovered that there were relatives who had been grave diggers in Inverness. This later appealed hugely to both Lee McQueen and Isabella Blow, who were attracted by death. She was also a watercolourist and doubtless Lee joined her later at the kitchen table.

Money was tight, but over the course of the next 15 years, Ronald and Joyce had five children. At the time of the birth of their sixth child, Lee Alexander in 1969, they were living in a London council flat, but they moved to Biggerstaff Road, in Stratford, East London while Lee was still an infant. Later, Lee attended Carpenters Road Primary School there.

Lee's brother Michael recalls the days when their father was a lorry driver working six days a week, rising at 5am and coming home at 9pm. Joyce did the family accounts. She was far more open minded and creative.

One of Lee's earliest memories was of drawing dresses on a piece of bare wall in his sister's bedroom in the block of flats in Stratford, at the early age of 3 – Cinderella in ball gowns – and later, he made dresses for his three sisters to wear at school. Sadly, Lee's interest in female clothes and birdwatching were hardly designed to endear him to his down-to-earth father, who was, said Lee's brother Michael *"quite draconian"*. Ronald, in fact, practically disowned his son from then on. Lee's mother, on the other hand, was always there to support and encourage him in his endeavours, and a lifelong closeness developed between them, a bond that was never to be broken. That bond both succored, and then upon her death, finally caused overwhelming pain to Lee.

THE EARLY YEARS 1969-1985

he tried to function, shaped the contradictory elements of Lee's character, elements that would later make and break him. He developed an inner strength and conviction about himself that later drove his visions, but retained a sensitive vulnerability to an outside world that he could not properly thread his personality into. The fate of countless artists throughout history.

By the age of 12, when he was already engrossed in books on design and fashion, escaping a difficult reality for the world of glamour, his future path was already beckoning to him. Rokeby Comprehensive School for boys, became less and less interesting. His attendance rates dropped; he was unable to concentrate on school work. Nonetheless, he was an avid reader and imagery could always hold his attention. His favourite music was House, and it is indicative that when he left school on the 17th March 1985 at the age of 16, the O-level exam that he had passed was in art.

His inauspicious start in life saw him clearing away beer mugs in a pub for his first wage packet, whilst he attended a local technical college. Mercifully for him, this sojourn into the harsh world of the unqualified worker was mercifully short; his mother was watching television and heard that there was a lack of apprentices on Savile Row. Wisely, she suggested that he apply for a position. Lee struck gold immediately by walking into the very firm that preferred apprentices who were not college graduates. By the end of his interview, he was hired.

Although he developed a great interest in swimming, at which he soon excelled, his real passion in life was obvious from an early age. Dressmaking. It is not too difficult to imagine his father's reaction when Lee finally admitted at the age of 18 that he was gay, nor that this admission drove the final wedge into their relationship. Subjected to bullying and unpleasant teasing at school, Lee was deprived of a positive male role model and male support when he needed it most. This difficult, hostile world in which

Thus, for £100 per week, armed with a thimble and a pair of shears, as scissors are known in the tailoring trade, Lee began his ascent to the pinnacle of the fashion world from the venerable rooms at number 30 Savile Row, for a firm that was stiffly traditional. Loftily standing aside from the hip London fashion scene, they were the outfitters to His Royal Highness the Prince of Wales, Prince Charles; Anderson and Sheppard.

FROM SAVILLE ROW TO MILAN 1985-1991

"I was never a big networker, but I was a spin doctor, all those shock shows, that's how I got my first backers. But fashion's a scary industry to be in, especially if you've not grown up with it."

McQueen had the great good fortune to be apprenticed to a master tailor; Cornelius 'Con' O'Callaghan was one of Anderson's best coat makers. The attention to detail required for a bespoke garment, wedded to McQueen's own talent, dedication and discipline, ensured that the young apprentice quickly mastered classic cuts and shapes, wielding chalk and shears with skill. So he progressed from learning how to pad an under collar, to understanding how to fit a collar, set a sleeve and insert linings and pockets. He was striving to produce a jacket known as a "forward" – an incomplete jacket, lacking a collar, and to which the sleeves have only been pasted in position, and the finishing stitching has yet to be done – which has to be approved by the apprentice's mentor. When an apprentice has reached this stage, his eye has been trained to appreciate spacial relationships between shapes and the effects produced by different colours, and he has gained the courage to tear away dubious workmanship and start again.

Not given to easy conversation, McQueen would arrive late in the morning and leave at around 5 in the afternoon. Inevitably, it must have seemed to him, his sexual orientation often led to teasing from the two girls who were also apprentices alongside him.

McQueen would credit his time at Savile Row with the tailors to royalty, for defining and honing his skills, which he described just a few years later as *"cut, proportion and colour"*. Here he learned to work with a variety of fabrics ranging from canvas or velvet to tweed. He became familiar with the weight of material and how different fabrics fall and sit. He was taught how to cut, to press and to deliver immaculate stitching. Of less importance to his immediate work but of vital significance to his future was the fact that he was the latest edition to a long line of the finest tailors, who had dressed the great and the good over many generations since 1906.

It was, however, his own intuition and ambition that told him that tradition was valuable but stagnation was not and that clothing needed to keep pace with each succeeding era in the same way that technology did.

McQueen completed his 'forward' in 1987, but his quietly determined streak of restlessness was not without repercussions. After his mother became ill at around the

same time and he had taken leave to be with her, Anderson and Sheppard informed him that they didn't think him reliable or committed enough for a long-term career with them and did not ask him to return. The conflicting reasons that he later gave for his departure, served to highlight the instability in his own nature.

McQueen's career then went into revolving door mode for a few years.

The next firm to take him on was Gieves and Hawkes, who were at number 1 Saville Row. Here, he was able to round out his tailoring skills, as a trouser cutter. Once again, he found himself at a venerable firm – Gieves was founded in 1785 and Hawkes in 1771 – and working in the wake of tailors who had dressed Admiral Lord Nelson and the Duke of Wellington, and this sense of tradition no doubt heightened his natural curiosity for the past. It also honed his contradictory attitudes towards the establishment, and when he left the firm on his 20th birthday, the 17th March 1989, he alleged that a *"homophobic"* atmosphere was the cause.

His budding interest in history was burnished when he was employed by Bermans and Nathan's later in 1989. The theatrical costumiers had been established in 1790, and while he was there, McQueen helped to make costumes for the musicals Miss Saigon and Les Miserables. His research on those projects led him to develop a passionate interest in the techniques, patterns and fabrics used in clothing in the 16th century.

From this point on, venerable tradition became a thing of the past for him. McQueen was to be thrust into the branch of fashion that was to propel him to fame, and his move to Mount Street on London's Mayfair, where the Japanese designer Koji Tatsuno apparently hired him on the spot later in 1989, acted as a springboard for McQueen's churning imagination. Koji Tatsuno had introduced his own brand,

Culture Shock, in 1982, developing a style which he described as *"ahead of its time"*. Here, McQueen came into contact with innovative tailoring. Fabrics were not the revered servants of tradition but wisps of the imagination; they were used to forge new shapes and were cut, torn, twisted or exploded into expressing the designer's will. The young Lee was exposed to a new world, watching Tatsuno send convention packing and allow his fantasy to run riot on the catwalk. McQueen was caught up in an irresistible bubble where a liberated imagination, theatricality, love of fabrics and the blending of these elements produced a unique style. There can be no doubt that McQueen was airlifted in the direction set by Tatsuno's weathervane.

THE FASHION ICONS McQUEEN

Already, McQueen's complex personality was in evidence; when his new employer described him, he used words such as *"intriguing"*, a *"very strong personality"*, *"interesting"*, and perhaps more perspicaciously, *"a twisted character"* who was determined to shock people with his work; a characteristic often embedded in a soul that is ill at ease with itself.

At this point, McQueen was a freelancer, accepting whatever work came his way, toiling as a pattern cutter and a machinist for the likes of John McKitterick and his brand 'Red or Dead'. McKitterick gives more insights into McQueen's closed personality, describing him as *"incredibly shy"*. He was not articulate and his rebelliousness expressed itself first and foremost in the unprepossessing baggy clothes that he wore. This, combined with the fact that he already had vast amounts of knowledge about the fashion world, was arrogantly confident in his own skills and was difficult to get along with, upset a lot of egos in the butterfly-fragile world of high fashion. None of this affected his work ethic with McKitterick, however. By all accounts, he was good at his job, well organised, always on time and never confrontational. It was McKitterick who opened the doors to the next phase of McQueen's career by giving him the names of contacts that he knew in Milan. Not that McKitterick thought Lee would be successful on his difficult quest.

With a one-way ticket in his pocket, the ambitious McQueen arrived at 10 Corso Como, Romeo Gigli's headquarters in Milan. It was McQueen's good fortune that Gigli was also enamoured of traditional tailoring, and Lee's experience in Savile Row now paid dividends. He was again hired immediately, no mean feat, as Gigli was a man who had been lauded as singlehandedly changing the course of fashion in the late 1980s.

Lee began working for Gigli as a pattern cutter, the skill that was later to become McQueen's forte. Employed by a man who loved art, travel, and books and who had an encyclopedic knowledge, whose neo-romantic, soft fashion creations were born of a love of history, art and sumptuousness, McQueen was introduced to a world that ran parallel to, and fed into, his own bubbling imagination.

The fault lines in his character that would later cause him to run off the rails became evident to the girls working alongside him at the time, who noticed that he made peculiar remarks about *"queers"*, whilst at the same time frequenting every gay club in Milan. His friendship with another design assistant at Romeo Gigli's also threw up an interesting aspect of McQueen's character. The two would exchange sketches; Lee's were often of an aggressive nature, such as the one of an almost naked woman with an arrow through her stomach.

Life under pressure in the cutting rooms could become fraught, with McQueen frustrated at the language barrier to communication. He was cutting alongside colleagues who were experienced and used to a certain way of working, whilst he found little room for manoeuvre in his drive towards open boundaries. Rumour told the story that Lee had once again written *"F... you"* into the lining of a prototype jacket.

When the season of 1991 was over, Gigli's firm was already foundering because the two partners, Gigli and Sozzani were going their separate ways. It was time for McQueen to return to London.

LONDON BECKONS
1991-1996

"British fashion is self-confident and fearless. It refuses to bow to commerce, thus generating a constant flow of new ideas whilst drawing in British heritage."

McQueen had no idea what was going to happen next, but his footsteps took him back to John McKitterick where 'Red or Dead' was producing its autumn-winter collection. It proved to be another pivotal staging post along the young McQueen's career trajectory. McKitterick was working on a collection with a fetish patina; leather, rivets and plastic providing the materials for tight-fitting and brightly coloured clothing. Perhaps McQueen suddenly realised that he was not alone with his creative imagination, that others were on the same wavelength. Whatever the reason, McQueen revealed that he wanted to become a designer, and he began to show his employer his ideas, plying McKitterick with questions about how and why the established fashion designer had produced various pieces of work.

McKitterick advised McQueen to go to art college and suggested that he contact a friend of his, Bobby Hillson, the woman who had created the MA course in fashion at Central St Martins College of Art and Design in London, the Mecca for young artists. McQueen was about to add the final piece to the mosaic of his years of learning, which would launch his career as a fashion designer.

There seems to be some discrepancy about who was responsible for taking on McQueen at Central St Martins. He intended to become a pattern cutter tutor but was then persuaded to join as a student. One version has the college's Louise Wilson drawing attention to him. The other says that Bobby Hillson was so impressed with the talent displayed in his portfolio that he was accepted for the eighteen-month course on the spot. Whatever happened, Lee's determination and obvious emotional electricity shone through, despite his lack of verbal skills.

But McQueen had missed the intake of scholarship students for the year, so he would have to finance the course himself. In this he was helped by his aunt Renee, who loaned him £4,000. This would not be enough to see him through, however, and he decided that he would have to draw welfare illegally to make ends meet, a decision that cast a constant fear of discovery right through to the very end of his time at Central St Martins and beyond.

That Central St Martins had an enormous influence on the artistic scene in London is an understatement when the like of Jarvis Cocker, P.J. Harvey, John Galliano, Alexander McQueen and Stella McCartney have issued forth from its rooms.

But Central St Martins had another pull for McQueen. He was *"obsessed"*, according to John McKitterick, with John Galliano. McQueen wanted to compete with him on equal terms and studying at the prestigious college was the first step to drawing level with Galliano. Galliano had also been a shy

boy who had suffered from bullying; he had gone to study at Central St Martins. His first collection had been bought by a well-known London boutique, Browns. For McQueen, the parallels in their personal lives were unmistakable, and later he would also emulate Galliano's joyous indulgence in night life. For now, Central St Martins was simply *"the place"* to go where Lee would finally be allowed to unburden his writhing imagination through his creativity, without hindrance. And according to Bobby Hillson, this McQueen did, showing an ability to interpret whatever inspired him that caught Hillson's attention.

Hillson knew that her new student's personality was going to be problematic, not least because of the fact that he was not an academic; and she was right. Lee did not find the eighteen months at Central St Martins easy. For one thing, he didn't hold back in voicing his personal convictions. Lecturers would feel the lash of his argumentative nature, and he was soon on a war footing with one of the teaching staff. But he stood out from his fellow students, and he was determined that his talent was not about to become a victim of issues secondary to his creativity.

Those who understood him, fellow student and textile designer Simon Ungless, for example, became close friends. They would read the Marquis de Sade's '120 Days of Sodom, or The School of Libertinism' together, which Ungless credits with influencing Lee to release the dark side of his character. McQueen is quoted as saying that the film of the book was his favourite movie. Fashion consultant Alice Smith recalls McQueen showing her a Victorian fetish pornography book stocked in the Central St Martins' library. McQueen saw himself in the role of holding the mirror up to society; he was also reflecting himself into the eyes of his fellow citizens.

THE FASHION ICONS McQUEEN

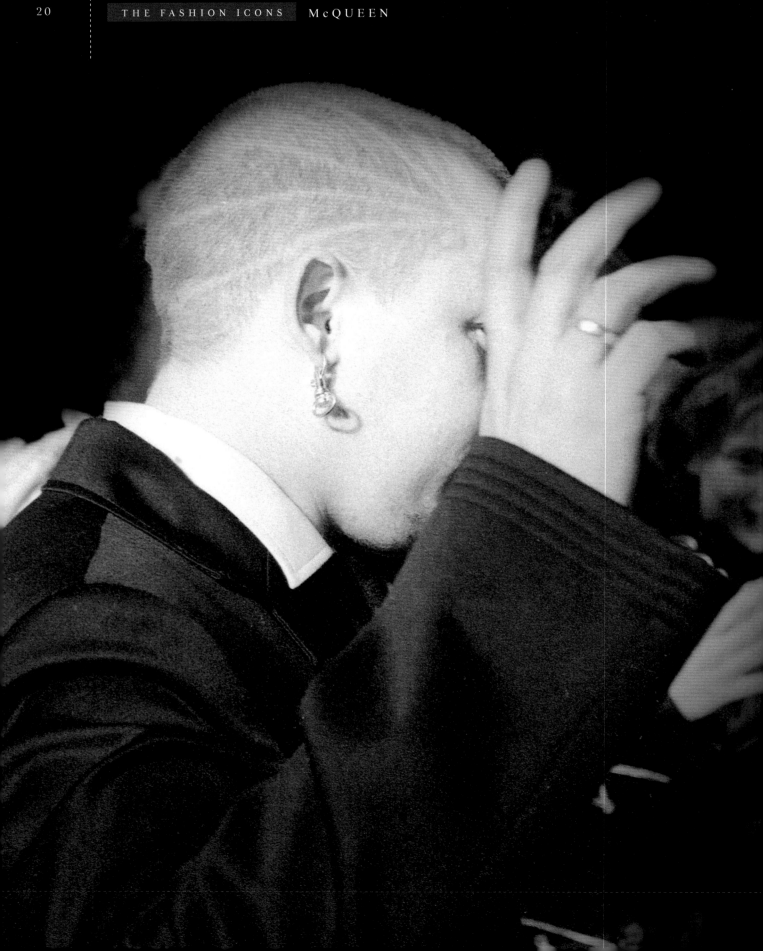

Ungless was also gay, so there was a common experience connecting them and later, the two shared a house. McQueen wanted to get as much as he could from the course, but he still found time to enjoy himself in the nightlife offered by the capital's gay clubs. Unfortunately, neither he nor Ungless fitted into the showy gay scene of the time, which led to McQueen being bullied yet again.

At Central St. Martins, however, McQueen rapidly developed his design skills, and in March 1992, his MA collection was ready. Inspired by his ancestral roots in London's East End, the theme he chose upon which to hang his creations was 'Jack the Ripper Stalks his Victims'. McQueen was focusing on shock tactics, combining death with sadomasochism, two themes apparently ever present in McQueen's mind. *"I find beauty in the grotesque. I have to force people to look at things"*, he said. He wanted extreme reactions to his creative output and he wanted people craving his work. Using shock was his dramatic method of getting the attention he wanted. From this moment on, his attitude to his materials and his models was accompanied either by the accusation that he downgraded women to distortions, victims, almost, at the hands of a male, or by admiration for what someone redefining the concept of beauty in fashion, in tandem with the female form, could create.

Opinion was divided on his very first show, with the general consensus being that it was good but not *"heart stopping"*, in the words of the head of Central St Martins, Jane Rapley. Bobby Hillson felt that he was almost ready to spark but needed just a little more time.

And then, after his mother and Bobby Hillson, along came the third woman in his life who was to prove indispensable to him, more so than anyone could possibly have realised at the time. Isabella Blow.

Isabella Delves Broughton was born in 1958 to Helen Shore and Sir Evelyn Delves Broughton and descended from a family with a 34,000-acre estate with a 14th century castle in Cheshire. She had married the art dealer Detmar Blow.

Isabella was a bohemian aristocrat. She was a freelance stylist at the time she met McQueen, already known for her fashion fearlessness. With her eye for talent, she would also be credited with 'discovering' John Galliano, Julien MacDonald, Stella Tennant, Sophie Dahl and milliners Stephen Jones and Philip Treacy, whom she constantly challenged to make hats that she could not wear. She was an academic with a 'punk rocker's anarchic sense' the editor of Tatler later said of her. The family motto was *"Nothing Happens by Being Mute"*. Isabella took that to heart. The designer Zac Posen claimed that *"thoughts of suicide were a big part of her existence and persona"*, adding that she saw it as her mission *"to better people's lives by exposing them to creativity"*. This she did with vivid passion.

And suicide was no doubt a recurring theme when she and McQueen spoke together; soul mates, in many ways. Blow was excited by talent and spectacular clothes that made a striking impact. McQueen was her made-to-measure designer.

The eccentric Isabella was enraptured with McQueen's 'Jack the Ripper' collection and wanted to buy it in its entirety. She watched it sitting on some stairs. She saw through the blood and paint to the tailoring, the skilled cut of the cloth, and plagued his mother with phone calls until McQueen relented and contacted her. She bought the entire collection for £5,000 and paid it off in monthly installments over a year. This must have pleased him enormously, as it went some way to equalling what had happened to John Galliano when Browns had bought Galliano's 1984 design-school graduation collection, "Les Incroyables" in its entirety.

But Isabella Blow's importance to Lee went far beyond the

simple purchase of a collection. Blow introduced Lee to everyone she knew, and the list of names was considerable; aristocrats, theatre people, artists, celebrities, important people in the fashion world. Thanks to her patronage and friendship, Lee received enormous publicity as the enfant terrible of British fashion, a tag that would make his name known worldwide.

In McQueen's six pieces for the MA collection show, he incorporated locks of his own hair into the clothing. This was a reference to the Victorian prostitutes who would sell locks of their hair, which would then be used as love tokens. As Galliano had done, he incorporated elements from history and blended them into his clothes. He produced a distressed calico skirt, a thorn print pink coat cut close to the body and also a black silk jacket fitted tightly to the waist. Blood was splattered about liberally as befitted clothing that had passed through the Ripper's hands. Freed from commercial constraints McQueen did not have to compromise and could *"interpret whatever inspired him"*, said Hillson. There was promise, but not yet polish.

Whatever the merits and demerits of the collection, once it was over McQueen had to find a job. His talents were recognised by Alice Smith and Cressida Pye of the London recruitment agency Denza. They had seen the MA show and recognised a star in the making, so they took him on. They eventually became his friends as well as his agents. At the time, he was still drawing money from the Department of Health and Social Security and it was the fear of discovery by them, he maintained, that led him to start using his middle name, Alexander, and not any prompting from Isabella Blow. If John McKitterick is to be believed, McQueen, in fact, loathed the name.

In the meantime, McQueen found work as assistant to Isabella Blow, who left no stone unturned in her attempts at finding McQueen a prestige position. She and Central St Martins had

infused the young man with greater self confidence and thus the ability to behave in a way that would further his ambition; now, he was able to network on his own. Not only did he know the names of relevant journalists, photographers and stylists, he was able to engage in conversation with them. Isabella Blow was so confident of the young designer's abilities, paired with his obvious love of his metier, that she urged him to set up on his own.

Again, it was Isabella Blow who was instrumental in getting 'Vogue' and her friends in to attend McQueen's first collection under his own name in 1993; 'Taxi Driver' was probably a reference to Ronald McQueen, his father, although at the time he pointed at the film of the same name made by Martin Scorsese in 1976 as the source of its inspiration.

"Taxi Driver" was, of necessity, a one-off showcase, because McQueen had no money to back up a production line or enter the world of couture. When it was shown in the offices of Smith and Pye and the Ritz afterwards, it filled just one clothes rack.

But already, with this first collection, McQueen had stamped his mark on the fashion world. His designs were unlike anything being made by his contemporaries; using a hint of fetishism, he included rust, shellac, human hair and locusts as decoration, and his work made a strong impression on his former mentor Bobby Hillson and also Katy England of Dazed and Confused magazine. Words such as *"groundbreaking"*, *"incredibly cool"*, or *"powerful"* were used to describe his work. Praise indeed at such an early stage in his career.

In contrast to the aggressive cuts that became the hallmark of his later work, this show illuminated a romantic side to McQueen. The models wore no shoes and the clothes were all in white.

Lee McQueen was emerging from the cocoon of his early life. He was now living in Essex in the ground floor flat that

LONDON BECKONS 1991-1996

belonged to his sister. Lee and his boyfriend Andrew Groves, who he had met in early 1994, would cut and make clothes in the living room, including the chiffon dresses they made for Pellicano. Lee became acquainted with the nobility of the London gay society. Much of his early work was inspired by his self-admitted over indulgence in London's bawdy nightlife scene. These London night-clubbing years surely brought him into contact with the fashion eccentrics that populated London at that time. A clear indication of this can be found in the similarities between his work and that of the legendary costume designer, performance artist and model, the Australian Leigh Bowery. McQueen worshipped Leigh, according to one member of Bowery's troop. Lee visited a performance of Bowery's group 'Minty' and was present at other performances given by the Australian. He also went to the London nightclub 'Kinky Gerlinky' where the audience was made up of gay, straight, fetish freaks and a host of others on the periphery of 'normal' society. Leigh Bowery had an enormous influence on Lee and, indeed, on an entire generation of artists; Bowery's outrageousness informed McQueen's concept of what could be done with a traditional fashion show. There were to be no boundaries, no taboos.

McQueen now saw himself as a provocateur, as being anarchistic, and he tapped into the anarchy of the street, of cool Britannia, of youth music and fed its thought patterns into his clothing designs. He was in tune with the times; he wanted to shake fashion out of its romantic cradle. The 'bumster' was one of the early manifestations of this thinking. So was the slightly sinister aura surrounding the Gothic aesthetic, which also appealed to McQueen, with its elements of unspoken fear and death.

With his next show, 'Nihilism', McQueen truly sparked off the controversy that would follow him throughout his career. Some sections of the press dubbed him a misogynist, whilst his defenders were quick to point out that Lee's women, his friends gay or straight, were powerful personalities and that McQueen loved women. Model Karlie Kloss remembers being told by him, *"You own the dress, the dress does not own you!"*

In his own words; *"I want to empower women. I want women to be afraid of the women I dress."* Spreading fear through his clothing may have been a way for the still inarticulate McQueen to hit back at a world that he felt had rejected him and still frightened him. It was also a yellow brick road to fame.

The 'bumster' made its 'low-rise' appearance in Lee's Spring-Summer 1994 collection, 'Nihilism'. Its use slowly spread through its adoption by famous figures such as Britney Spears. Despite the obvious inspiration being the infamous "builders bum", the late 1500s was also a period when it was fashionable to place the waistbands of men's britches below the hips, and McQueen commented, *"It wasn't about showing the bum... to me ... the bottom of the spine – that's the most erotic part of anyone's body, man or woman"*. The waistband of the bumster sat a further 2 inches below the top of a hipster even, and the homoerotic inspiration could not have been lost on anyone who saw it.

Whether the collection was inspired by an inherent desire to subjugate and reduce women, or to liberate them, the collection drew descriptions such as *"a catalogue of horrors"* for its exploration of the themes of physical harm. The violence done to the cloth, which was often ripped and slashed, combined with the sharpness of tailoring, was seen as an attack on women. The 'Nihilism' collection was not designed to be worn; the whole point of it was to shock, and in delivering that shock, McQueen put his name before a wider public in the fashion pages.

By the summer of 1994, McQueen and Groves had moved into the basement of 67 Elizabeth Street in London's Belgravia; the apartment belonged to Isabella Blow. There was still the problem, however, of how to get backing for his next collection in the autumn. McQueen went into action and managed to get sponsorship from Beck's beer company and found an empty warehouse at King's Cross to use for the show.

This third collection was important because journalists would look to see if the promise of the earlier days had been maintained. McQueen did not disappoint. 'Banshee' (the name refers to a fairy woman in Irish mythology who wails when someone is about to die; in Scotland's mythology she is seen washing the bloodstained armour or clothes of those who are about to pass over to the other side) did not lack clothing intended to fan the flames of controversy. Draped in a sumptuous black gown, a pregnant model with a shaved head (beauty, aggression and sex were never far from McQueen's thoughts – exposed buttocks were once again in evidence) walked down the same runway on which Isabella Blow herself would shortly appear in a black chiffon dress with a cream waistcoat. The message was clear; you do not need to be a skinny model to wear McQueen's clothes.

'Banshee' proved that McQueen could work with a whole range of fabrics, because he presented a variety of clothing from knitwear to fishnet dresses, evening wear to full length gowns of organza; the tailoring was, once again, flawless. It captured the attention of the mainstream fashion press. Mission accomplished.

Whilst McQueen's star rose, by the autumn of 1994, British Vogue were no longer prepared to countenance Isabella's profligacy with their money, nor her whimsical nature and she had to leave. On one of her photo shoots the budget had reached almost $130,000. That year, she would be heard to say, *"I'm so unhappy. I'm so unhappy."*

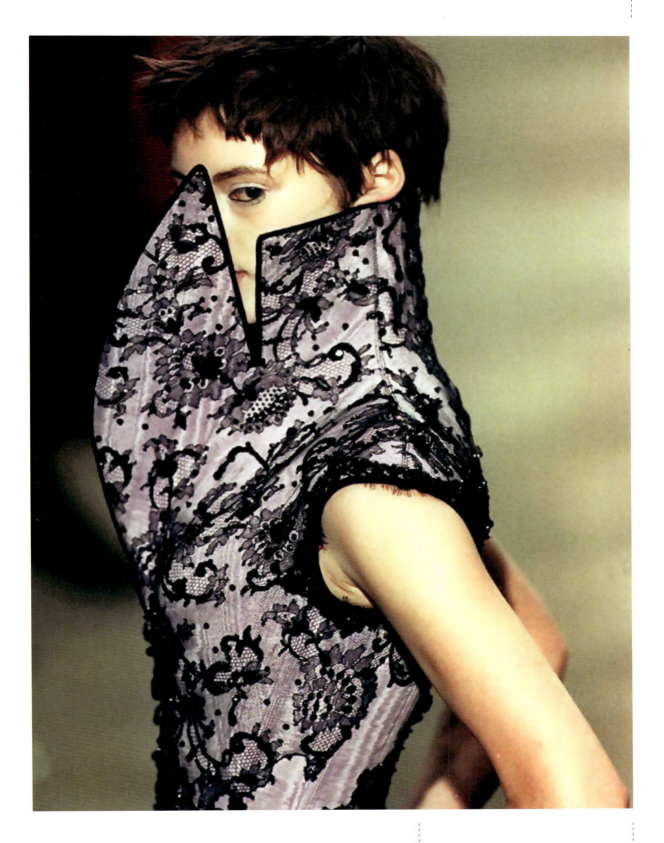

ABOVE: Autumn/Winter 1996 "Dante"

When McQueen made his spring-summer 1995 collection, 'The Birds', he did so together with Andrew Groves, David Kappo and art director Simon Costin, using Simon Ungless's prints. The title came from Alfred Hitchcock's 1963 film of the same name. The birds in this case were swallows, and the runway was painted with white lines to imitate a road. Violence, in the form of models bearing tyre tread marks, a reference to roadkill, stoked the flames of controversy once more. As usual, there was no money for the collection so Ungless used fabrics taken from Central St Martins where he worked. McQueen's shows had as much to do with theatre as with fashion, and the narrative that informed the shows was produced as a performance piece that added to the dramatic aesthetic of his clothing. One of his models was a man dressed as a woman, in this case the master couture corsetiere, Mr. Pearl, as McQueen toyed with the notions of exchangeability of beauty and gender.

'The Birds' attracted accolades; the new force in British fashion, was one comment in Vogue. McQueen was on the cusp of a breakthrough.

That breakthrough came with his autumn-winter show of 1995. Its title alone was provocative; 'Highland Rape'. Although McQueen's Scottishness had been filtered through many generations having lived in England, he was still very aware and proud of his heritage and Scotland's tragic past. Scotland and Scottish issues were much to the fore that year with calls for a Scottish Parliament and two blockbuster films about Scottish heroes being released; Braveheart and Rob Roy. The brutality inherent in the word 'rape', of course, did nothing to dampen the critical fires that flared, with accusations that McQueen was once again degrading women and simply revisiting the Scottish theme that Vivienne Westwood had already covered. McQueen maintained, however, that he was exploring the rape of a nation and its culture and that his collection was not a broadside against women but intended as a counterweight to what he saw as the faux romanticism of Westwood's collection.

With Katy England now his stylist – she became a vital element in the design and styling of McQueen's shows – and a PR representative in the shape of Trino Verkade, low-cut 'bumsters', cigarette butts and McQueen tartan were on view in 'Highland Rape' at the London Fashion Week tent, the first time McQueen had shown a collection there. Some thirty pieces were presented, thanks to models, stylists and make-up artists who worked for free; McQueen was unable to produce more because of the time-consuming detailing required in matching the weaves whilst working the tartan. McQueen anchored his reputation with this collection, a reputation for combining radical new ideas with skilled tailoring techniques.

The collection may have had the fashion elite "frozen like rabbits" as the London Evening Standard noted, but his clothes were becoming increasingly popular. Women were raving about the dresses ripped at the bust, according to Katy England. The tent was heaving with people, inside and out.

Once more, this was a collection designed to shock, and it did. Androgynous models, elements adapted from the Stuart period, tartan, gauze and naked breasts were all on show.

At the time, the young designer was in dire financial straits. After the show, he collected all the clothes in bin liners and took them to his flat. He then had a visit from the bailiffs, who confiscated his possessions, including those bags of clothes from the show. It was a low point, but he only had to stay on course and the rewards would come.

Soon after the collection was shown, a fashion sales agency from Turin, Italy, Eo Bocci, offered McQueen £10,000 for a stake in his company. Although he turned it down, the agency agreed to deal with production and sales in Italy, which meant that McQueen would be able to concentrate his attention on his work knowing that his clothes would be available in the shops. The shock tactics had paid dividends.

LONDON BECKONS 1991-1996

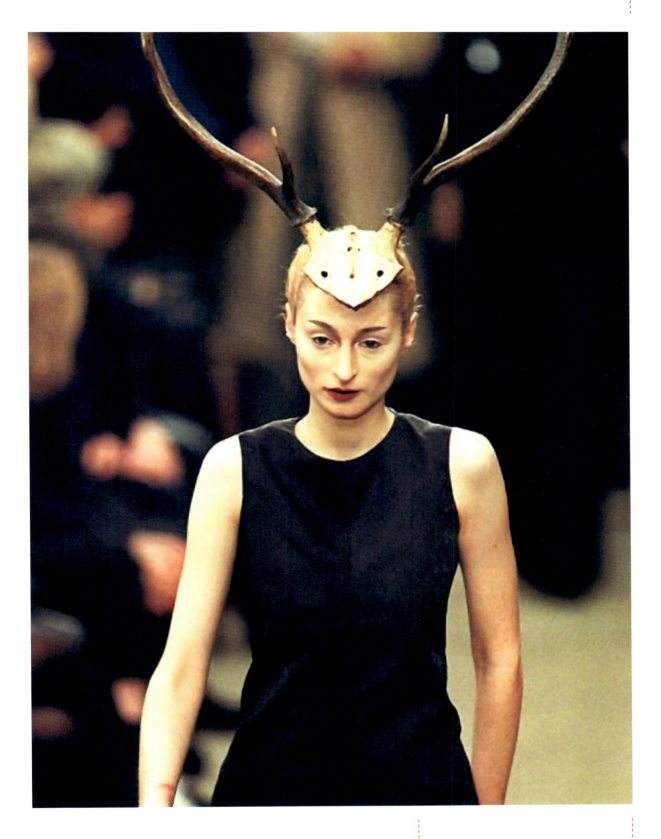

ABOVE: Autumn/Winter 1996 "Dante"

THE FASHION ICONS | McQUEEN

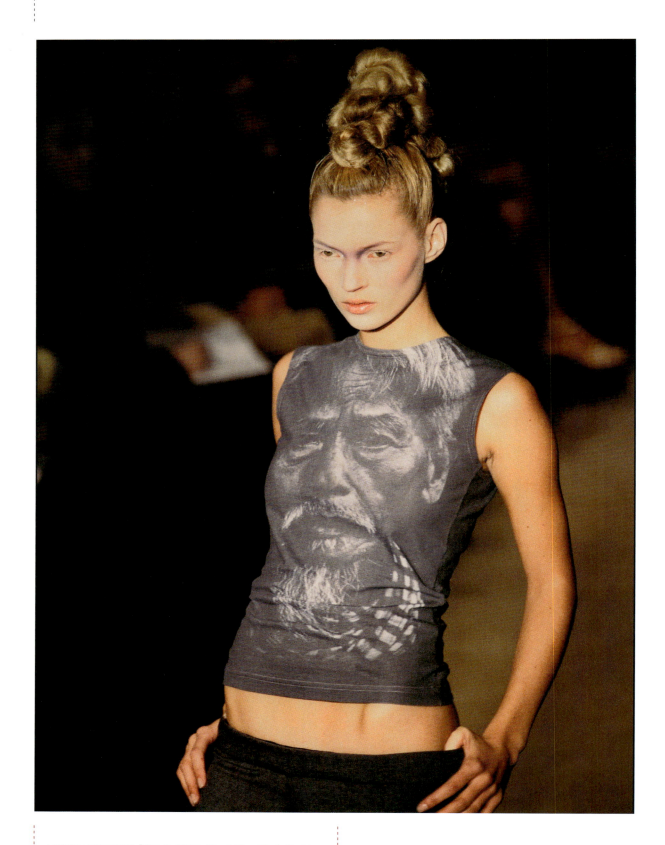

ABOVE AND RIGHT: March 1996: First New York fashion show at a former synagogue on Norfolk Street

LONDON BECKONS 1991-1996

THE FASHION ICONS McQUEEN

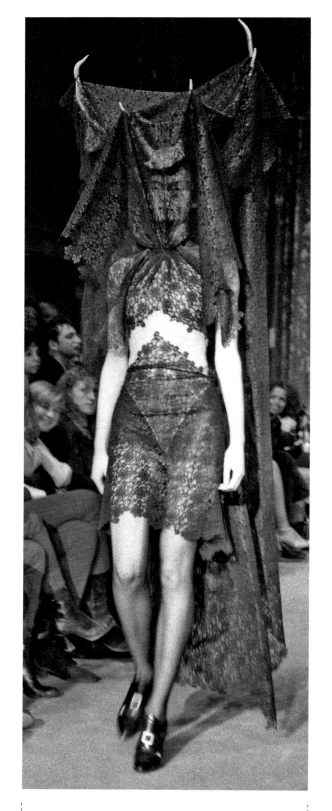

ABOVE AND RIGHT: March 1996: First New York fashion show at a former synagogue on Norfolk Street

LONDON BECKONS 1991-1996

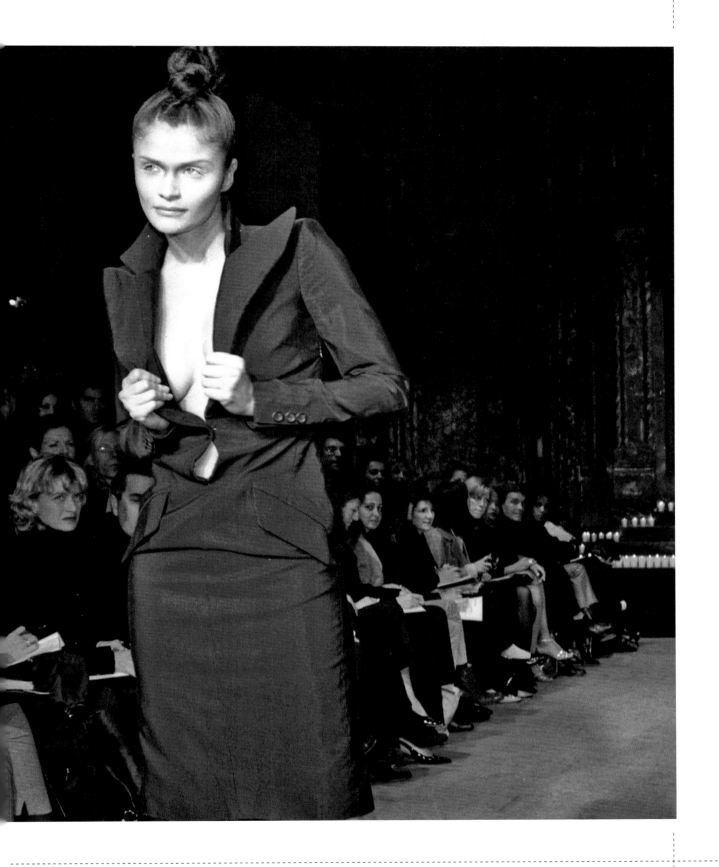

THE FASHION ICONS McQUEEN

THE GIVENCHY YEARS 1996-2001

"Of course I make mistakes. I'm human. If I didn't make mistakes I'd never learn. You can only go forward by making mistakes."

1996 was a life-changing year for Lee Alexander McQueen. He was 27 years old and this was the year that he was asked to join Givenchy, the prestigious Paris fashion house with whom he was to stay until March 2001. Isabella Blow had suggested McQueen for the job of designer at Givenchy in 1995, when the founder of the company Hubert de Givenchy had retired. Who had been chosen instead? Of all people, John Galliano. Galliano was now moving on to Maison Dior.

At home with his boyfriend, McQueen received a phone call; would he be interested in the job at Givenchy?

Having made disparaging remarks about the job the year before when Galliano had accepted it, calling it *"... a boring thing"*, McQueen now had to eat his words. Perhaps he accepted the position because he would be succeeding his eternal bugbear, John Galliano. Perhaps he was flattered by the attention of this elite firm, and the offer pandered to his own reverse snobbery; he was doubtless persuaded that this was a chance to enhance his international reputation. The offer of one million pounds over two years also helped to sway McQueen.

It was not a marriage made in heaven. Those voices whispering that his way of thinking was incompatible with the snobbery of Paris were eventually vindicated. Immediately following his appointment, everyone acknowledged that the combination was a completely ill-advised disaster in the making. The culturally incompatible blend of an extremely class-conscious French company and a man perceived to be an ill-mannered taxi-driver's son who hailed from the back streets of London, was a mutually toxic arrangement. McQueen was fraught with the angst of compromised creativity and caught in a friendless situation that was exacerbated by his own uncensored character and insulting manner.

Katy England was asked to go with him to Paris. Isabella Blow was ignored and, at a time when she needed help, left feeling ill-treated as a friend who had done so much to get him to where he was.

McQueen's work at Givenchy would not be as edgy as it had been up until then, but he still managed to cause a stir with his shows. Even so, the relationship between the street kid and the fashion oligarchs at Givenchy soured. McQueen was predictably dismissive after his contract ended and stated later, *"It was just money to me"*. Paris was not McQueen's town. He felt that he was a London lad and said that his inspiration came from the streets of the British capital; that was where his life was. Yet Paris was where he staged his shows until he died.

The initial signs from Paris had been good; McQueen was now counted amongst the ranks of important fashion designers, and he won the British Designer of the Year award on October

THE GIVENCHY YEARS 1996-2001

the 22nd 1996 for the first time. Galliano had won in 1986, so at last McQueen could now consider himself on a level with the other London kid. Alice Smith reported that he looked very shy and disbelieving at the Albert Hall before he received his award dressed in his own, anti-fashionable attire.

Ironically, McQueen's next show, the spring-summer collection 1996, which bore the name of 'The Hunger', was described as *"a mess"* and was certainly not one of McQueen's best efforts. With models, professional and non-professional, giving a V sign and holding up a middle finger to the audience, the show proved that artistic talent acting without restraint or direction can wander into self-indulgence and irrelevancy. Worms were squeezed between the two pieces of plastic of a breastplate; breasts sagged; one dress was cut to resemble female genitals. Perhaps, mused the fashion historian Judith Watt,

"the balance between commerciality and art was not there". But for McQueen, creativity was all, and he publicly defended every designer's right to pursue it unfettered. *"When you are designing with a buyer in mind, the collection doesn't work"*, he said.

In contrast, the autumn-winter show of 1996, 'Dante', produced what the International Herald Tribune described as a *"fashion moment"*, best described as the pinnacle of achievement for every fashion designer. Inspired by Flemish paintings of the 14th and 15th centuries, the models in 'Dante' walked in standing collars and slashed sleeves, wearing T-shirts with prints from war photos, black masks bearing a Christ-like crucified figure, chiffon and braid. With Stella Tennant carrying a hooded falcon on her arm, McQueen's interest in birds, but also Isabella Blow's role as cultural mentor was evident; Blow

was still taking her protégé to see works of art that found their way into his designs and taking him to her world in the country where hunting had been part of life for centuries and history was palpable.

A model bearing huge antlers was another iconic reference to Blow's influence and McQueen's interest in extravagant headwear. Mongolian lamb on a camel coat and lavender silk showed that McQueen, the edgy 'bad boy' was also attracted by luxury. With critical acclaim, the last piece of the puzzle had fallen into place.

His new employer offered to buy McQueen's company. McQueen refused.

Ominously, McQueen was feeling the effects of fashion world stress even at this early stage in his career and it was causing him emotional problems. The immediate answer was on hand; hard drugs were easily available in this hedonistic, ego-driven world and he sought relief, too, in anonymous sex. The changes in his character had been dramatic and as a result, he had already lost many of his old friends. But fame and fortune are insatiable beasts and care nothing for personal problems. Once on the treadmill it is wise to don a coat of iron. McQueen could not.

In 1997, the rapidly rising star of the fashion world launched his own menswear line and 1997 brought more highlights, not the least of which was his second Designer of the Year award. As fate would have it, this was shared with ... of course; John Galliano.

He presented his collection, 'Bellmer la Poupée' for spring-summer 1997 in the Royal Horticultural Hall in Victoria, London. Its central idea came from a series of deconstructed dolls which had then been reassembled in a very fetishist manner and photographed. This was the work of German artist Hans Bellmer. The dolls became McQueen's models, who strode through water on the runway in slashed trousers or a net dress shackled by a metal frame to simulate a broken doll walking. Many of the models had their movements restricted in some manner. High collars and extended hip lines made an early career appearance. The press saw oppression. The remainder of the collection was commercial; silvery, slinky and colourful. Innovative and independent of spirit; that was the McQueen that Givenchy wanted.

McQueen started out on his Givenchy adventure with Katy England, assistant Catherine Brickhill and art director Simon Costin.

He was contracted to produce four collections a year, and his stated aim was to restore *"sophisticated wearability"*. Advised by Simon Ungless to abandon his first designs, which he called *"very bad"*, McQueen settled on Greek mythology to carry the first collection, due just eleven weeks after he started work; the 19th January 1997.

The fifty-five pieces presented under the theme of Jason and the Argonauts was manifested primarily in white and gold. Sumptuously cut dresses paraded with ram's horn and cashmere, and coiffed hair was surmounted with extravagant headgear created by the Irishman Philip Treacy.

Opinion was mixed; the show was either a disaster or beautiful, the designer either arrogant and ignorant or able to eclipse Karl Lagerfeld at Chanel. McQueen came down on the side of the dissenters and in a Vogue interview in October called the show in no uncertain terms, *"Crap"*. Not a good start.

It did seem that the staging of the shows was causing more of a stir in the established fashion world than the skill of the designs themselves. Fashionistas, however, were hungry for the new, young, edgy designers.

McQueen's autumn-winter show 1997, drew accusations

THE GIVENCHY YEARS 1996-2001

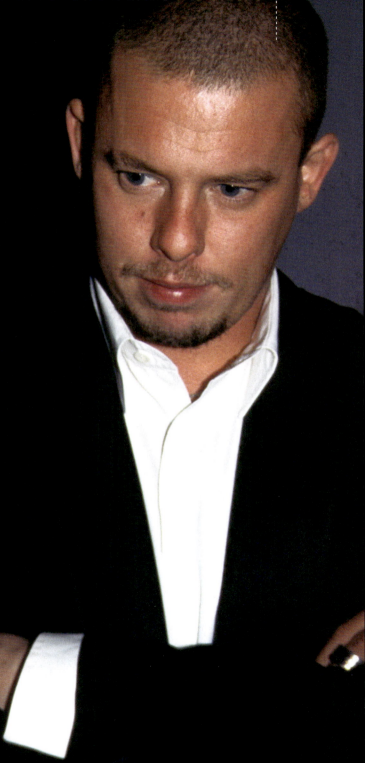

that it lacked soul, the result of trying to be a servant to two masters with opposing ideals. *"Sexual energy... is important"*, said McQueen, presenting long coats in military style, pencil skirts split high up on the thigh, long heels and leather coats. Unrestrained sexual energy, what Isabella Blow called the *"peeping Tom"* element that explored the body's erogenous zones, was certainly never far away in the collections of a man whose favourite theme was, ostensibly, prostitution.

Unsurprisingly, the Givenchy customers did not buy into the McQueen revolution and kept their hands out of their purses. They felt that Givenchy had a confident style of its own which did not need turning on its head. Ivana Trump encapsulated the problem when she said that the 'soul of Givenchy' did not reside in McQueen's breast.

McQueen now confessed that he had been missing the point; that in a life that could be very difficult, people wanted to see female beauty, there was enough madness, enough pain in life already. McQueen had wanted to work at Givenchy and undergone a road to Damascus conversion to luxury. *"I think people want that now,"* he said. *"They don't want to look as though they bought all their clothes in a thrift shop."* He was growing up. But, he was pandering to the very thing he purported to denigrate. He was caught in hypocrisy. He worked and earned in a world that was fed by those who caused the very things he purported to disdain; those people supported him. He became elitist himself, the antithesis of what he struggled to remain, a street boy with his feet on the ground. This schism tortured him; this unresolved riddle of life.

Indeed, he seemed to be slightly desperate as he searched for themes on which to hang his clothes that would bring him success. Cowgirls, Blade Runner, 2001-A Space Odyssey, sport and punks were brought in to help over the years. To no avail. The relationship with Givenchy was going nowhere. Lee's working class, anti-establishment ethics – he loved his tattoos, rings and earrings and their connection to tribal belonging –

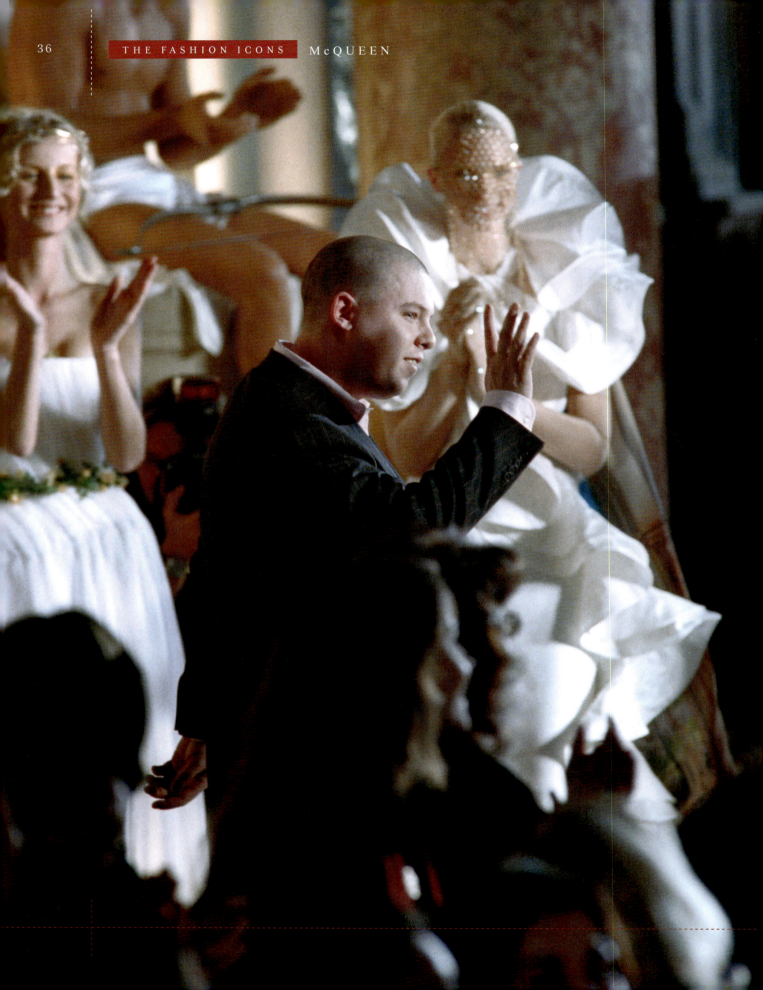

the dichotomy in his nature, the desire to be part of the group and the desire to be outside of it, was a conflict that was never resolved, that could not be sufficiently focused to satisfy his new employer's needs. McQueen was now the target of photographers' lenses wherever he went. His life was changing dramatically. How would it affect him? Simon Ungless thought that McQueen was beginning to believe what he read about himself in the press and be upset by it.

The autumn-winter 1997 collection for Givenchy was called 'Eclect Dissect'. Inspiration for the collection came from Edgar Allan Poe, live ravens sat in cages on the runway, and from a tale of a man dissecting women and reassembling them; an extension of the thinking behind the 'La Poupée' show. The central theme of the show was a woman who had come back to life and was now haunting the killer. The set, owing its provenance to The Cabinet of Doctor Caligari, a film made in 1920, boasted blood-red curtains and oriental carpeting on the floor.

There was real fur on show, tartan, black crinoline to the knee and the bird theme featured strongly, in a pheasant feather hat by Philip Treacy, for example. There were elements of gothic, Japanese in the form of a kimono with a corseted bodice, African, and a dragon gown in Chinese silk with ermine tails. But the headpieces and wigs were the stars; they were startlingly dramatic.

Negative criticism skulked in some corners of the fashion press and although McQueen called his work sexual and sensual and not macabre, the label 'Macabre McQueen' was soon attached to him.

He was, inevitably, also called the Dr. Jekyll and Mr. Hyde of fashion.

In London with his own shows, he could let his talent flow more freely. But for the spring-summer 1998 collection he ran into trouble with his sponsors and had to withdraw the name he had wanted to use, 'Golden Shower', which had more to do with sadomasochism than the moneymen were happy with. So, it was known simply as 'Untitled'.

Whatever he did, McQueen could not escape the 'degradation of women' tag and it came up again after "Untitled". In that show, men wore corsets and skirts once more, a nod to the evolution of menswear, and bare breasts were in evidence, displayed by Stella Tennant dressed in strips of suede. Golden rain showered down upon the models, of whom Kate Moss in white muslin was one, and they walked with makeup running down their faces.

By the time the autumn-winter 1998/1999 collection arrived, the theme was evident; strong women. The show was entitled 'Joan' in a clear reference to Joan of Arc, with Mary Queen of Scots, elements of the Edwardian era and the murdered Russian Romanov family thrown in for good measure, enforcing the sense of tragedy and death that was an obsession with both McQueen and Isabella Blow. Long elegant dresses and prints, greys and blacks started the show. Androgynous male models in long black coats, dresses and jackets, long hair flowing, shared the catwalk with their female counterparts. The colour red became more pronounced as the show progressed and red contact lenses made the models' eyes glow in their pale skin as they paraded a waterfall of fabrics from snakeskin to tartan, knitted leathers and denim, with 'armour' made of black leather to represent medieval Joan. She reappeared in a head covering and red beaded dress, surrounded by flames at the end. High necks and wide shoulders featured. This predominantly black and red show, restrained in view of McQueen's later productions, was considered to have delivered a strong London trend. The designer walked to the end of the catwalk when it was over.

Lee, however, was a mind in trouble. He was wallowing in self-pity and in this state, his thoughts dwelt on physical disability.

THE FASHION ICONS McQUEEN

THE GIVENCHY YEARS 1996-2001

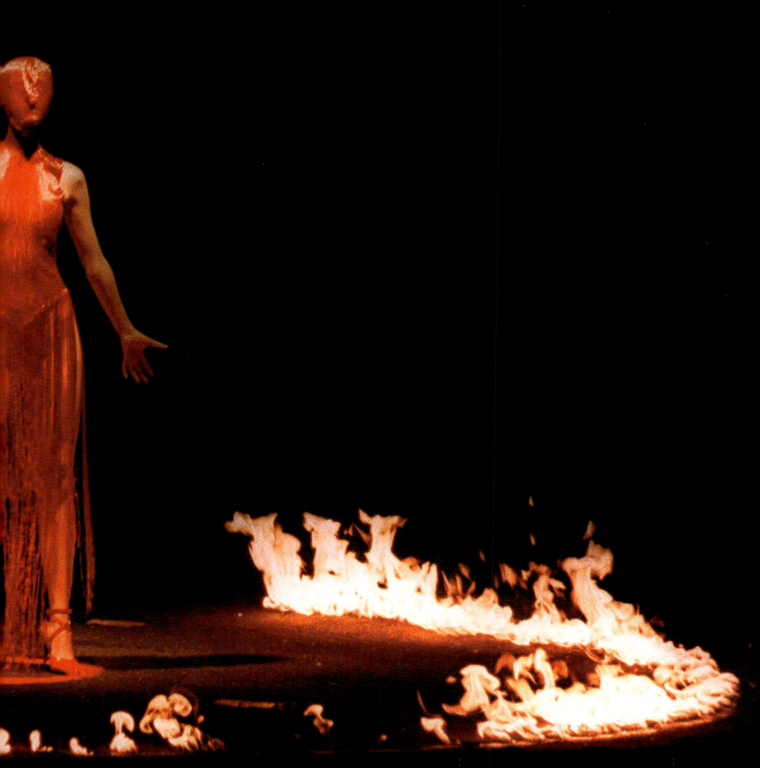

ABOVE: Autumn/Winter 1998 Finale of "Joan"

His brooding soon crystalised and could not be dissolved even by expressing it in a firework display of fabrics.

Behind the scenes, McQueen's crudeness was paralysing. He once famously swore at model Eva Herzigová sending her in tears to the runway. When a boyfriend tried to commit suicide, McQueen's reaction was *"How dare he try to kill himself in my fucking house?"*

He used cocaine constantly and would call, said Eric Lanuit, the press officer at Givenchy, *"… to ask for certain 'vitamin substances. I'm not talking about vitamin C, I'm talking about cocaine."* Those around him tried to prevent his use of the drugs, for their own self preservation. McQueen was "off his head" to quote one source. He had become *"… uncontrollable. In a mad way … the stories you used to find out … Oh God, that guy really needed help"*, said designer Julien MacDonald who eventually took over from McQueen at Givenchy.

In 1998, McQueen branched out and was guest editor for issue 46 of the style magazine Dazed and Confused. He took the opportunity to explore the concept of beauty in the light of physical disability. The publication went on to outsell all previous issues.

Leading on from this, McQueen continued the theme in his spring-summer 1999 show and provided the fashion world with another of those 'moments'.

In 'No. 13', world-class athlete Aimee Mullins was one of the models, and she walked the runway, avoiding spinning discs and with her neck in a leather bodice, wearing rigid wooden boots that McQueen had made, decorated with Grinling Gibbons-style carvings. (Grinling Gibbons was a Dutch-British sculptor and wood carver born in Rotterdam on the 4th of April 1648. He died on the 3rd of August 1721. Amongst his best known works are those he carried out in England at St Paul's Cathedral, Hampton Court Palace and Blenheim Palace.)

But the spectacular element was that Aimee's legs had been amputated when she was just one year old. Unless they already knew, no one would have realised at the time. And that was the point of the show; what is the relevance of a perfect body? *"Beauty comes from within"*, said McQueen.

Mullins was a strong woman of the kind that McQueen said he wanted to dress, and she approved of the image he wanted to promote. The clothes were lauded as his best ever, clothes that all women would love to wear; frock coats, chiffon, leather skirts, transparent dresses and long draping cocktail dresses. The finale was another piece of headline showmanship. The model Shalom Harlow stood on a turntable and her strapless white dress, belted at the bust, was sprayed in black and green fluorescent ink by two industrial robot paint sprayers from Fiat.

McQueen declared that it had been his best show and the only one that had made him cry.

A measure of how successful he had become was the fact that American Vogue editor Anna Wintour attended his autumn-winter show of 1999. 'The Overlook' was presented in a landscape of whiteness and artificial snow; black and white dominated the collection. It was romantic; 1,000 candles filled the air with their aroma and with a – not too overwhelming – sinister tinge, wolves howling and wind whistling were the soundtrack to the show. With one eye on his own shop, which opened at 47 Conduit Street in London in October 1999, McQueen knew that commerciality was more important than shock tactics this time; so pinstriped suits, pink parkers and pleated skirts found their places amongst the quilted and padded coats, spiked heels and a coiled body corset.

With his decision to show his spring-summer 2000 collection in New York causing a few raised eyebrows, the fashion world was abuzz with rumours about what kind of theatrical sparks McQueen would come up with. In fact, nature came up with something far more spectacular in the shape of hurricane

THE GIVENCHY YEARS 1996-2001

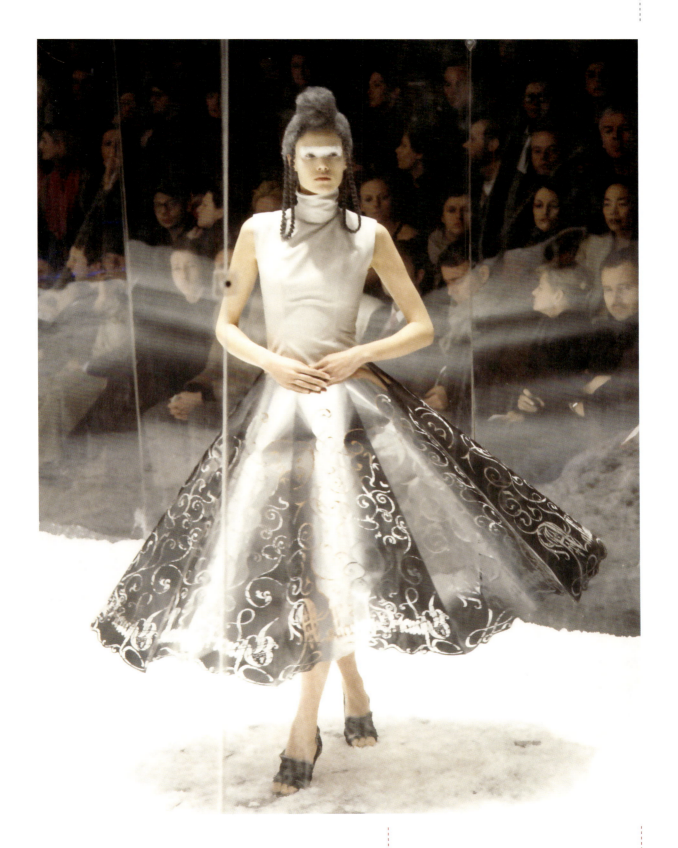

ABOVE: Autumn/Winter 1999 "The Overlook"

THE FASHION ICONS McQUEEN

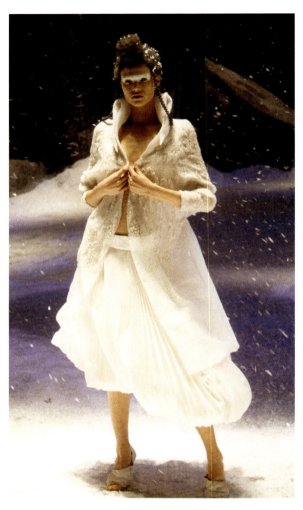

Floyd. Unlike many designers, McQueen decided not to cancel his show. It was called "The Eye", and was encapsulated in a sentence by fashion curator Andrew Bolton who stated after Lee's death that, *"McQueen's collections often channelled our cultural anxieties and uncertainties"*. The cultural anxieties concerned Islam. Models walked along a runway filled with water dyed with black ink, which finally turned into a terrifying bed of nails above which the models were suspended from ropes and pulleys. Arabic script, lacework trousers, burqas and mediaeval-style armour paraded along the catwalk; a scantily clad model was masked in a silver imitation niqab and another wore a masculine jacket and a McQueen version of a niqab, vividly illustrating the clash between East and West, the treatment of male and female, overt and covert sexuality.

Some, however, interpreted the display as being another sexual statement. The question asked was, is McQueen succumbing to self-indulgent showmanship or clever at using clothing in a politically relevant way.

Stung by the criticism, McQueen's comment was *"Fuck 'em"*. He decided that he wouldn't be coming back to New York. In England he felt understood.

The year 2000 had been a landmark for the *"overly-romantic"* McQueen, as he described himself. He had 'married'. Lee had met the 22-year-old George Forsyth, who was working as a documentary film maker, in a gay bar in 1999 and now Lee had proposed to him and been accepted. Even though McQueen

ABOVE: Autumn/Winter 1999 "The Overlook"

maintained that *"I can't get sucked into that celebrity thing, because I think it's crass"*, his actions didn't always support his words. The 'marriage' was celebrated with top stars in abundance, such as Noel Gallagher, Patsy Kensit and Jude Law – McQueen was by then the toast of the world of glitter – on a three-storey yacht in Ibiza harbour.

Lee enjoyed this lavish lifestyle and spending money, once famously spending £250,000 on two Andy Warhol pictures. However, he wisely did not open up personally to these showbiz acquaintances.

Back in London, McQueen stayed with African themes for his autumn–winter 2000 collection. The clash of colonial intrusion into native cultures was the overall thrust of 'Eshu'; Eshu was a deity in Africa and Latin America, the personification of death. McQueen was quoted as saying that he wanted to break down barriers that prevented people in the West from seeing the exotic clothing of unfamiliar cultures as anything more than mere costuming. In this, the mind of his former employer Romeo Gigli could be detected.

On this occasion, rather than relying on shock tactics, McQueen allowed the clothes and the music to relay the message. In a collection inspired by the Yoruba people of West Africa, the models walked on shale, which made for an uncertain footfall. Colours that were associated with the vast continent, gold stripes on the models' foreheads, gentle browns and whites, reflected Africa's wealth and resources, and the look throughout was romantic and smooth. Figure-hugging dresses and leathers, long trousers and knee-high boots were certainly more in tune with The Lion King than Hammer Horror despite Eshu's association with the underworld.

By the September of 2000, rumours about the tensions between McQueen and Givenchy were in widespread circulation. McQueen sold a 51% stake in his company to Gucci, Givenchy's great adversary. It was the result of a contact that he was urged to pursue by the indomitable Isabella Blow, still his 'lion rampant' despite all that had happened between them. £50 million, plus £1 million per season was McQueen's reward, and the investment would buoy up McQueen's reputation extremely well.

Away from the spotlight, Lee and his partner George celebrated the deal in a very McQueen way; with beer and chips.

That month also brought the spring-summer 2001 collection 'Voss' and what was generally considered to be one of the designer's most exciting shows. Voss was a Norwegian town primarily known as an ornithologist's paradise. Unsurprisingly, McQueen had come back to one of his favourite themes; birds and the slightly sinister nature behind their beautiful form.

The catwalk turned out to be a giant glass case. McQueen took childish pleasure in the fact that the audience were forced to look at themselves before the show started, an hour late. The models inside the glass could not see out, and they had been instructed to look confused and scratch at the glass as they paraded the 76 pieces that ranged from commercial suits, jackets and trousers to exotic ostrich feathers and a stunning Japanese screen dress surmounted by a spray of silver and berries crafted by Shaun Leane. Colours ranged from muted to the brilliant red worn by British supermodel Erin O'Connor. The piece de resistance, however, was a glass case holding writer Michelle Olley lying on a chaise longue, masked and naked, surrounded by moths with medical tubing snaking from her mouth. At the end of the show, the sides of the glass case fell and smashed releasing the moths. The tableau was a reiteration of his mantra that beauty comes from within. It was not at all hard to recognise McQueen's revenge – the Sunday Times had called him the *"podgy elephant terrible"* of British fashion – on those who saw fat as ugly. Ironically, McQueen had slimmed down by this time having resorted to liposuction. He had held the mirror up to himself and not enjoyed what he saw there.

THE FASHION ICONS McQUEEN

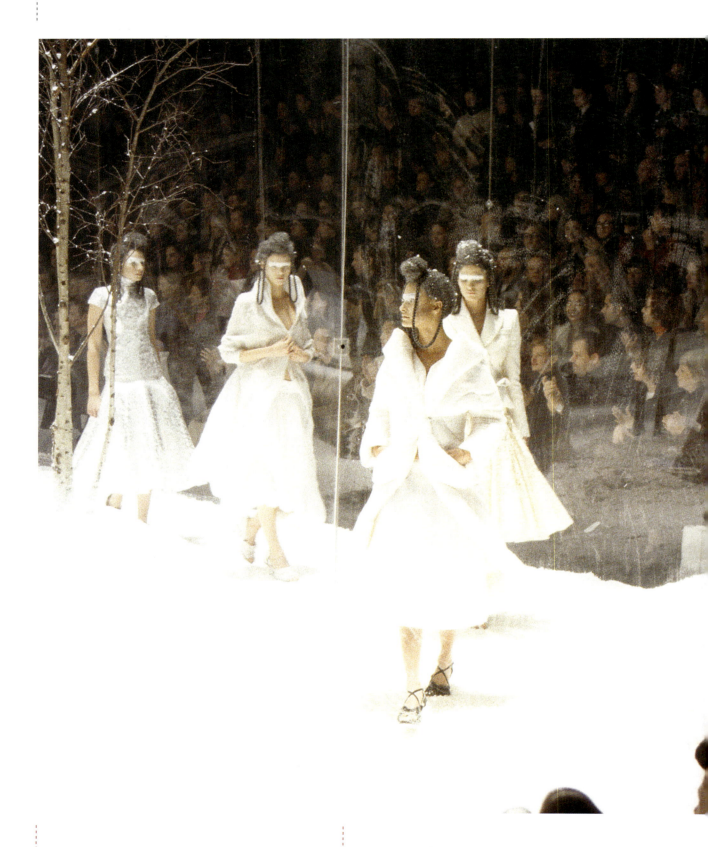

ABOVE AND RIGHT: Autumn/Winter 1999 "The Overlook"

THE GIVENCHY YEARS 1996-2001

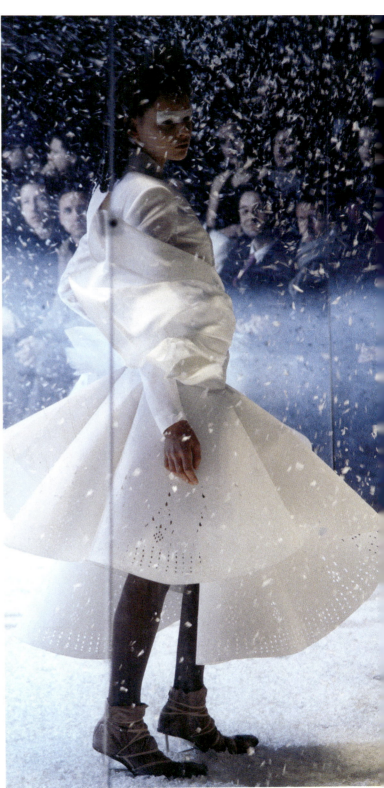

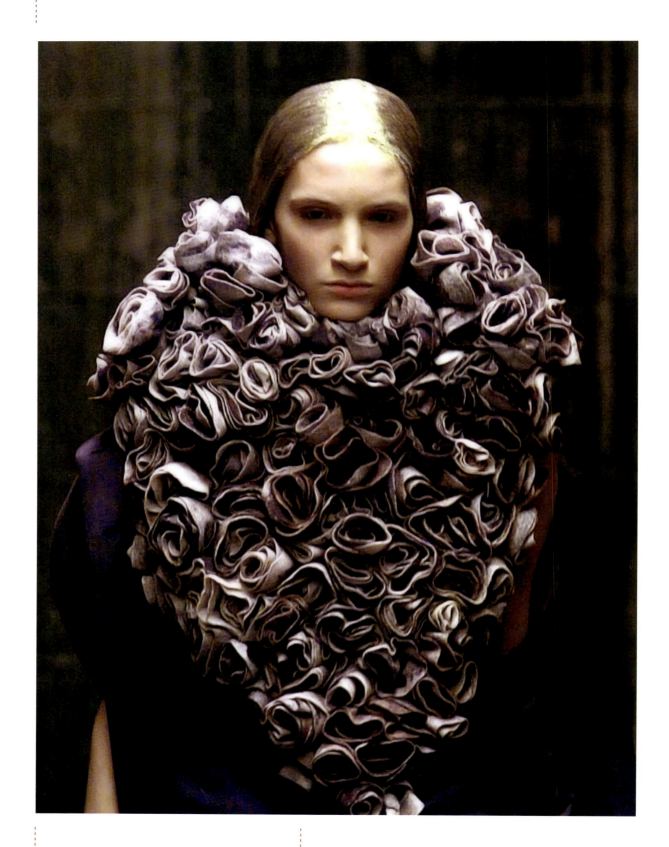

ABOVE AND RIGHT: Autumn/Winter 2000 "Eshu"

THE GIVENCHY YEARS 1996-2001

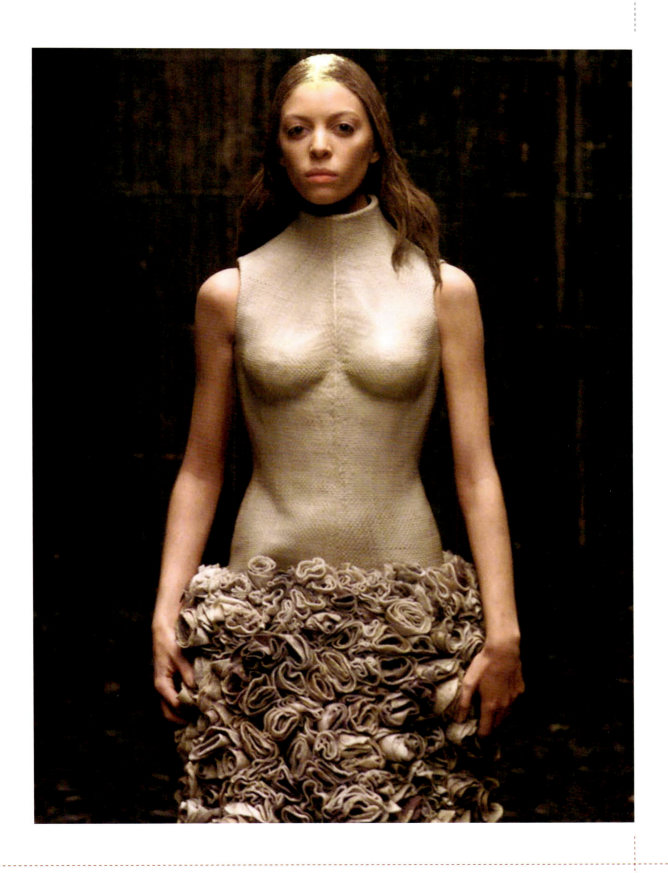

48 | THE FASHION ICONS | McQUEEN

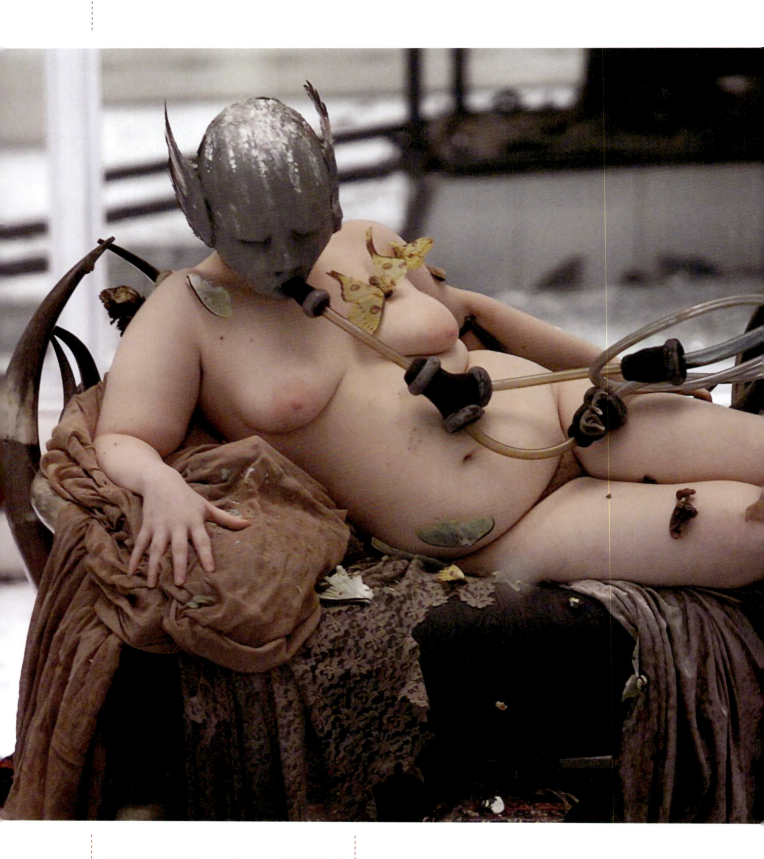

ABOVE AND RIGHT: Spring/Summer 2001 "Voss"

THE GIVENCHY YEARS 1996-2001

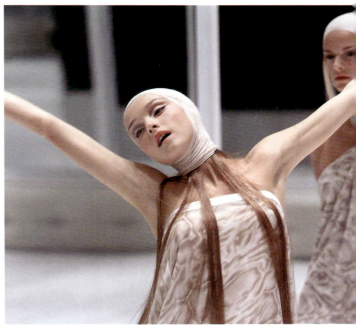
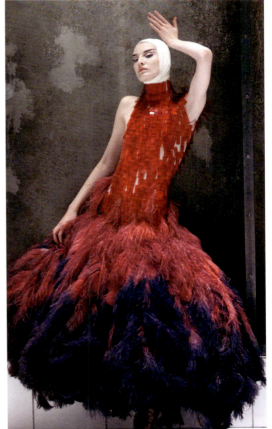

THE FASHION ICONS McQUEEN

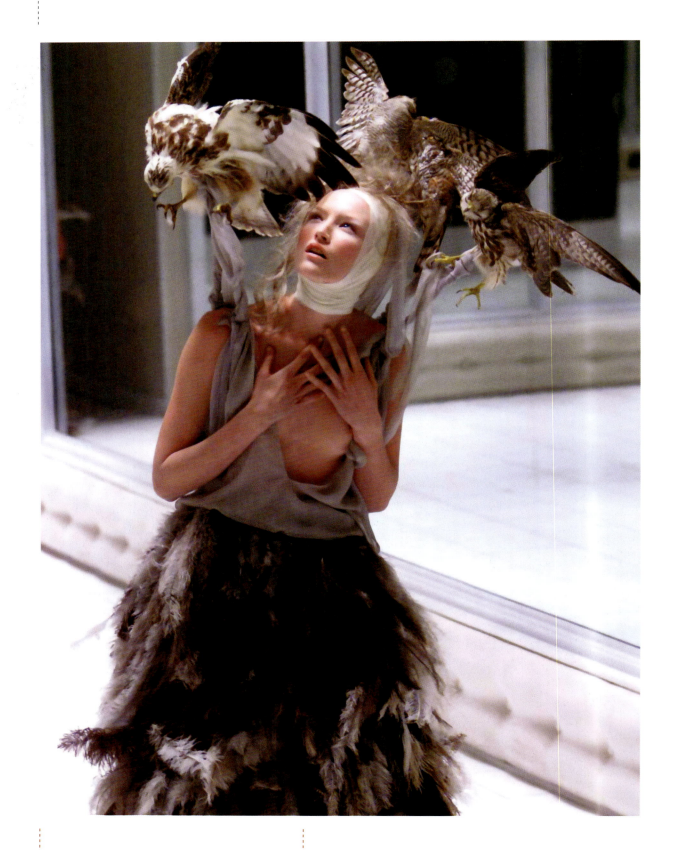

ABOVE AND RIGHT: Spring/Summer 2001 "Voss"

THE GIVENCHY YEARS 1996-2001

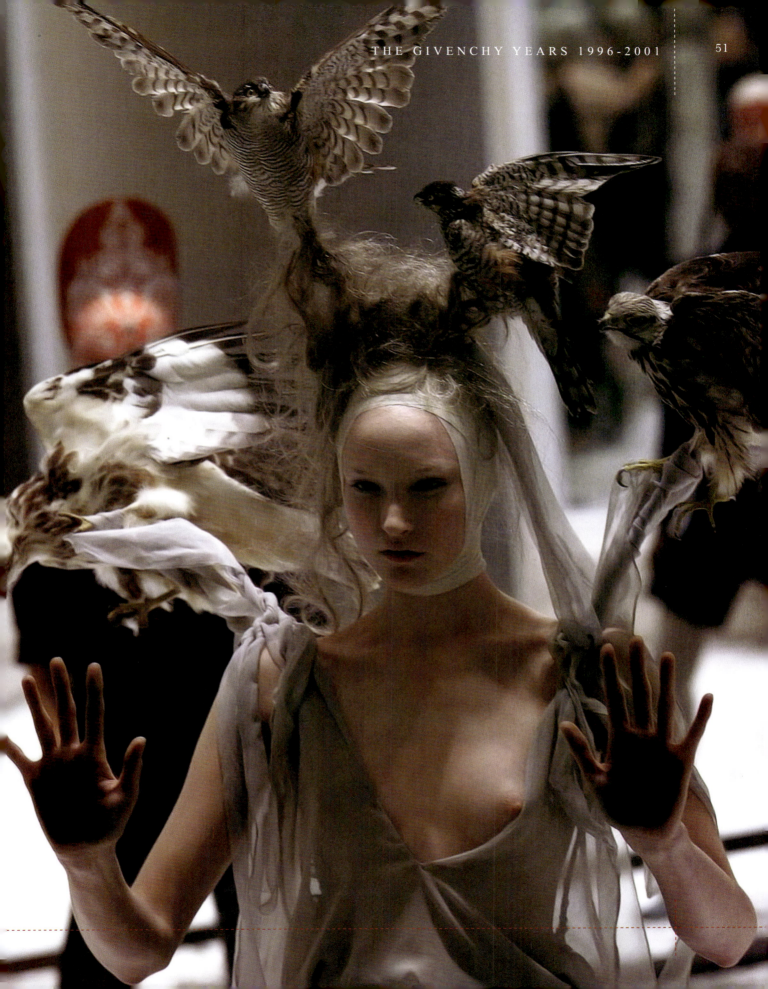

THE FASHION ICONS McQUEEN

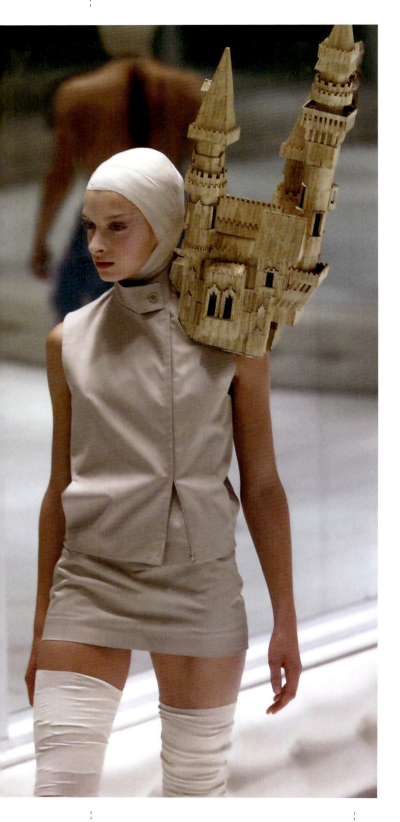
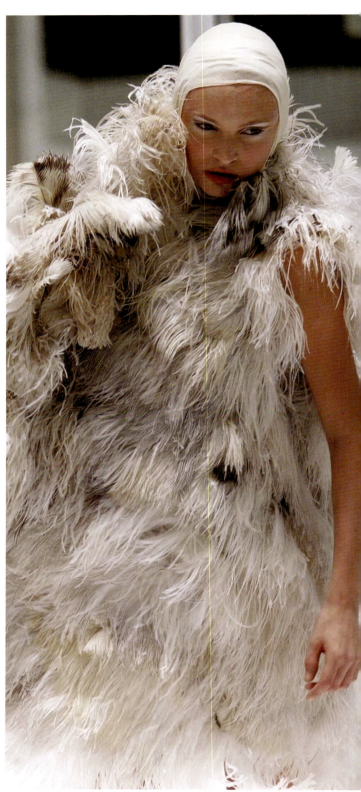

ABOVE AND RIGHT: Spring/Summer 2001 "Voss"

THE GIVENCHY YEARS 1996-2001

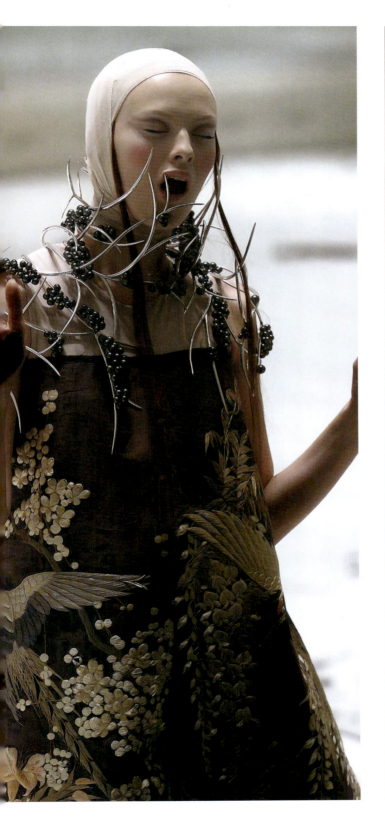
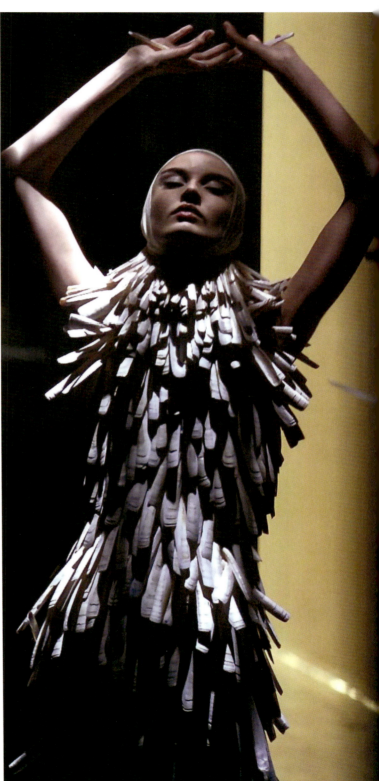

THE FASHION ICONS McQUEEN

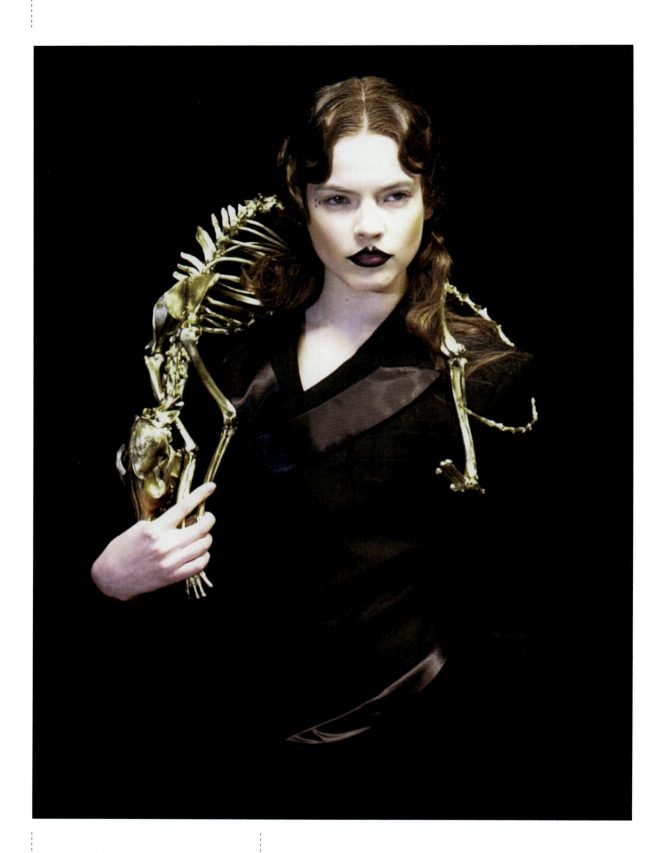

ABOVE AND RIGHT: Autumn/Winter 2001
"What A Merry-Go-Round"

THE GIVENCHY YEARS 1996-2001

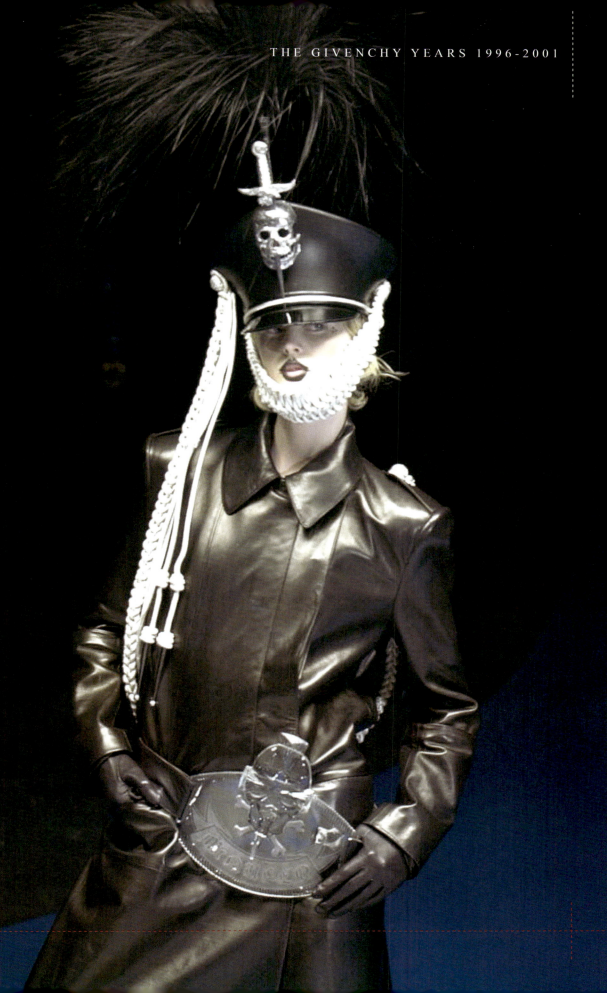

UNBOUNDED FAME 2001-2006

"Fuck French Fashion!"

Characteristically, McQueen was to strike verbally out when he felt wronged by France's fashion aficionados. Yet, he was drawn towards the things he dismissed like a moth to a flame. It seemed such an outbreak was more a stamp of the foot than a principled breach. In the same way that he would return to New York having dismissed it, he would show his collections in Paris for the rest of his life.

In February 2001, the British Fashion Council awarded McQueen the Designer of the Year title for the third time, and hot on the heels of that came his autumn-winter 2001/02 collection. It proved to be a finalé. McQueen had signed a deal with Gucci just before the 'What a Merry-Go-Round' show.

As ever, using the negative strains in his life – *"whatever is happening in my life comes out in my work"* – upon which to base his designs, French culture was a red thread throughout the show; he brought on 'Marianne' at the end, almost bare breasted, which might have been a dig at Givenchy but fitted well into his asserted penchant for strong women.

The eight-horse carousel he set up for 'What a Merry-Go-Round', was not the roundabout of cheerful childhood memory but rather one distilled from the vampire film Nosferatu. And the upright poles were just begging McQueen to be used as phallic symbols. He did not disappoint.

His commercial clothes displayed beautifully cut trousers and military-themed shirts, braid, sashes and jackets from the era of the French Revolution, and the French tricolour appeared in leather. McQueen was acknowledged to be one of the first designers to successfully graft the military look onto the fashions of the modern era. The skull and crossbones motif that was to become a McQueen trademark appeared in headwear and on a black knitted dress.

As the show progressed, the commercial gave way to the theme of the threatening clown, the man behind the mask being *"ugly and scary"* according to McQueen. He emphasised this with exaggerated, joker-esque white and black makeup, and to ram home the point, one model dragged a gilded skeleton behind her. At the end of the show, McQueen pointedly shook hands with Domenico de Sole of the Gucci Group.

In March 2001, Givenchy announced that the McQueen collection would be abandoned and replaced with two low key shows. The love affair had turned sour long before; now it was well and truly over. McQueen's reign in Paris died a strangulated death.

His attitudes changed as his own fortunes did and the man who had tried to make women look frightening was now very happy to make them look as romantic and pretty as everyone else was doing that season. His designs were finding their way onto Liv Tyler and Gwyneth Paltrow. But what of Isabella Blow, now that McQueen's star was in the giddy heavens? She felt neglected by her friend and disliked by his team and felt that he was trying to control her with his lack of appreciation for her

role in his success; perhaps he felt that he was a big boy now and did not like the fact that a woman, or indeed, anyone, had helped him to get where he was? She certainly resented his tightness with money and refusal to share any of his financial success with her, even as a gesture between, ostensibly, close friends. Isabella never treated him so brusquely.

By this time, McQueen had been well and truly seduced by the lifestyle; the decadence went on unabated. He was fast becoming exactly what he had always protested that he abhorred; demanding, materialistic, egotistical, aggressive; a man seeking status and the approval of the elite of the fashion world. Art director Simon Costin thought that McQueen was bipolar. *"He was up and down a lot more, harder to work with."* And if anyone dared to question or answered back or said 'don't be ridiculous', they were dead wood as far as Lee was concerned and never seen around him again.

Disliking France and French fashion or not, he, treading the same path as Galliano before him, realised that Paris was an important fashion town and could not be ignored. He decided to show his collections in Paris and did so for the rest of his life.

His first show after the break with Givenchy, was entitled *"The Dance of the Twisted Bull"*. A statement that *"women should look like women and a piece of cardboard has no sexuality"*, was telling; one accusation aimed at him was that he diluted femininity so that it became one dimensional. Yet he often attempted to blur the boundaries between male and female as well. Was it a problem for him, always being dependent on women to maintain his fame and display his creativity?

The backdrop for "The Dance of the Twisted Bull" was bullfighting; the clothes were subdued in McQueen's terms. He promised to *"strike"* later; for the moment, he said, he was testing the waters of his new world and his new masters. So the models came on wearing clothes that referred to Gaudi, the bullfight and flamenco, in flaming reds and deep

blacks, *"hot and sexy"*. There were tricorn hats and matador jackets, frills, tassels, ruched skirts, large dots, stripes, virginal whites and high heels. The most daring piece of the evening, alongside a smattering of bare breasts, was the layered, spotted red and white dress with a long train born aloft by two banderillas. But the rampant masculine preening involved in bullfighting accorded well with McQueen's *"dark and aggressive sexual energy"*, said the writer Kristin Knox.

The *"strike"*, then, was the autumn-winter collection of 2002/03, "Supercalifragilisticexpialidocious", which illuminated another theme, perhaps typical of McQueen; incarceration. In a semi-fairytale world, schoolgirl erotica and the dominatrix, who

shared the runway with the French musketeers, drove the show – held at La Concierge, where Marie Antoinette had been imprisoned. Reminiscent of little red riding hood, a model in a purple poncho leading two dogs was first onto the runway. Meanwhile, caged dogs prowled in the half light at the back of the runway. There were full denim outfits and slim-fitting trousers; skirts and dresses covered torsos held by leather straps. These were followed by a more assertive black leather thigh-high boots look, by way of an introduction to the models made up and dressed like St Trinian's schoolgirls with attitude. Less of a *"strike"* than an offering to male fantasy.

By this time, buyers were falling over themselves to get hold of McQueen's creations, and he was praised by de Sole of Gucci, not only for his *"great talent"* but also for understanding the business side of the fashion industry. The side that every designer eventually has to accept or vanish. McQueen did not want to vanish. He was opening shops all over the world.

McQueen was, of course, becoming increasingly polished and sophisticated in his designs. He turned to water again for 'Irere', his spring-summer 2003 collection, inspired by pirates, the Amazon rainforests and the magical, brilliant colouring of tropical birds. He used film to set the atmosphere; a girl underwater swimming to shore, reminiscent of Shakespeare's 'The Tempest'. The initial look was very feminine; loose, waif-like, frilled and increasingly colourful. This section ended abruptly with black taking over and bringing with it more overt sexuality, unusual headgear and sleek design. Another abrupt change; now, vibrant colours were on display to the sound of birdsong. Patterns swirled around lusciously cut dresses, the models' hair had been released and was full and topped with exotic Philip Treacy headgear. Vibrating yellows and reds exploded into rainbow ruches of chiffon and fringes with loose material flowing along the models' legs. It was one of the most gorgeous, eye-pleasing displays McQueen had created.

Now that he was a global brand, a PR girl was beside McQueen to keep him gagged. His corporate veneer was as far from the street kid image as it could be. But McQueen maintained that if he could not remain *"honest"* then he would not do it. But *"honest"* is a moveable feast, so Gucci need not have worried about that statement indicating that their star was going to burst the bubble. Nonetheless, the pressure on McQueen from the friction caused by commercialism clashing with free artistry continued to increase. So did personal pressures.

It was a known fact that McQueen was constantly on a drug high. He never succeeded in kicking his cocaine addiction. By 2003, Isabella Blow was suffering from severe depression, and in March, McQueen and Shaun Leane had taken her to the North London Priory Hospital to receive treatment. McQueen believed that her husband, Detmar Blow was a stone in the path of Isabella's way to recovery, because he was encouraging his wife to undergo electroconvulsive therapy. McQueen, therefore, made it a condition of his help that Isabella part from her husband. Isabella was torn emotionally by the men in her life, and her thoughts about suicide became ever more obsessive.

McQueen's own personal life was not damaging his fame. What greater sign that the mouthy kid had moved off the street and into the establishment than to receive an award from the Queen of Great Britain. On June the 16th 2003, McQueen's name was on the Queen's birthday honours list and he received the CBE – Commander of the Most Excellent Order of the British Empire. He did it for his mum and dad he said, so side-stepping the difficult topic of tacit acceptance of the Empire's violent past, not least towards Scotland.

This year was filled with awards, as the CFDA's International Designer of the Year award came his way in 2003 as well. On top of that he earned his fourth British Designer of the Year award.

Moving into autumn-winter 2003/04, McQueen chose models

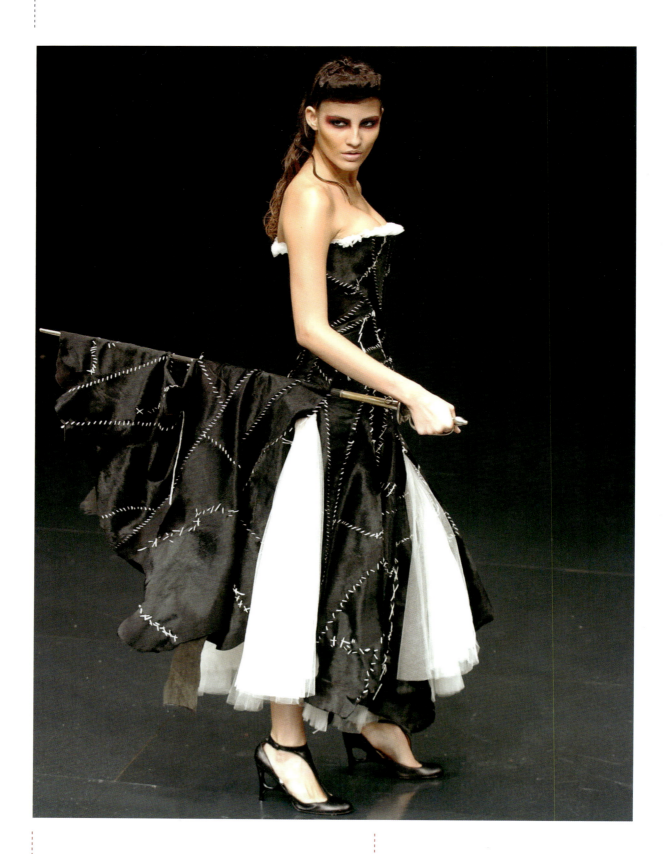

ABOVE: Spring/Summer 2002 "The Dance of The Twisted Bull"

with chiselled faces to show his Nordic-themed collection 'Scanners'. Accompanied by a howling wind soundtrack, the clothes incorporated antiquity into modernity, and covered periods from the samurai to 20th century cartoons. The wastes of the tundra were imitated to set off, but not distract from, the designs in Jute, fur, wool and chiffon. The earth-in-winter colours set the scene for what was, refreshingly, probably the least aggressively sexual of the shows until then. Checks and pleats were in abundance. Black was accorded its own section once more with superb designs. 'Scanners' was a tour de force of theatricality; at one point, a model clad in a leather bodysuit, hauled a parachute-like trail behind her in a raised wind tunnel, drawing audible gasps from spectators. It was as much the presentation as the product that made these shows so memorable and in this, the designer was superbly floated by his team; they were as one; it was impossible to see the joins between McQueen's ideas and those of his team.

The wind tunnel heralded a change to saturated reds; an allusion to the midnight sun of the North, maybe. The patterns were delicious and the tailoring as superb as ever.

'Scanners' was a maturing McQueen finding eloquence within the 'confines' of a commercialised world. Unfortunately, he had not learned that making statements such as, *"I am going to take you on journeys that you've never dreamed were possible"*, creates enormous expectation that is difficult to satisfy. It was a statement that would have been more at home in Steven Spielberg's world than fashion. Perhaps, though, these phrases were his way of trying to fight back at and make sense of the *"glass box"* that he now felt enclosed him, of trying to elicit some meaning for his personal life from the glamour and fame.

Both Tom Ford and Domenico de Sole left the group that was in charge of Gucci that year. They had both been enthusiastic supporters of McQueen behind the scenes, so this left a hole in Lee's circle of influential 'in house' friends; in the case of de Sole, a friend who had made McQueen's name known over the globe. Lee turned down the chance to take over as creative director at Yves Saint Laurent to attend to his own label.

For the spring-summer 2004 collection, the designer delved into the recent past of the American Great Depression era with clothing inspired by the film of 'They Shoot Horses Don't They'? The era was a suitable vehicle to explore the theme of beauty flowering amidst distress, a theme that McQueen was always ready to illuminate. In 'Deliverence', the conflict of wealth and poverty was illustrated at the end of the show by a dancer/model wearing the same clothes that the model at the beginning had worn; in between, there had been a panorama of clothes on display from sportswear to haute couture. Lamé evening dresses rubbed shoulders with simple dresses, coats and leggings, (sequins being a uniting factor) and denim sportswear.

Choreographed by a Scottish dancer, Michael Clark, models rehearsed for one week prior to the showing to learn dance steps, for a performance in three parts; the ballroom, the marathon and the finalists. The dance movements involved dictated the tailoring, superb as ever, so close-fitting styles mostly yielded to looser cuts; skirts and dresses were created that swirled when the model twisted around her partner; colours graded from muted greys to sumptuous oranges.

The models, male and female, were sent rushing down the runway to display the sportswear range; the girls were not spared high heels or flowing dresses even now. Vivacious yellows and pinks then gave way to more muted colours, long dresses and checked shirts with models imitating exhaustion and equally, decay as a result of the excess and overindulgence of the privileged of the age. The show was received with huge enthusiasm.

A side note to McQueen's 2004 year, came at Earls Court in London on the 3rd of June 2004, when he hosted a fashion

show marking the fifth anniversary of the black American Express Centurion card. The black theme show for the night was very much to McQueen's taste, and he produced an imitation chain mail piece that covered the face, revealed bare nipples and created a one-piece black leather bodysuit with cut out, long-lined patterning, which allowed a lot of room for the imagination to run riot over the female body. Kate Moss displayed another McQueen signature icon, the skull, printed onto a long, nipple-exposing dress.

It could be that McQueen felt the staging of the show was detracting from attention being fixed on the clothes on the runway, because for his next collection, autumn-winter 2004/05, 'Pantheon as Lecum', he turned away from theatrical presentation; despite the Greek overtones of the title and the opportunity for larger-than-life displays. It transpired that everyone enjoyed McQueen's theatrical presentation and the result was disappointed critics.

He returned to his models with pale faces, their little-girl ringlet wigs emphasising the subtlety, intimacy, and respect for tradition inherent in this collection. Hips were freed from excess material and revealed their curved sensuality. A selection of predominantly modern garments were paraded in neutral-palette, sand, earth and flesh-toned colours. In softly feminine materials there were clenched waists, tweeds and leathers, jumpsuits and padded skirts with the emphasis on slim length.

Only in the final section did McQueen deviate from this style to present futuristic design that had grown out of the designs of earlier centuries. Tudor, in one instance.

Some critics dismissed the show. Others were glad of the 'normalcy'.

Isabella Blow was reconciled with her husband Detmar Blow in June of 2004, an event that no doubt added to McQueen's stress levels. He would take himself off to his home near Hastings to spend time alone and wind down from the constant work demanded of him. He was no longer the free spirit sniping from the back alleys, he was a commercial workhorse in the service of corporatism, and it was not a role he enjoyed, being servant to two masters.

Nonetheless, he eventually moved to preferring *"intellectual cred"* to *"street cred"*; neither could he resist taking commercial opportunity; the former 'bad boy' was now launching new scents called Kingdom and My Queen, and by 2005, he was collaborating with Puma, helping to create a new line of trainers. There is usually a time limit on shock tactics; it is the fate of every would-be crusader at the walls of the establishment.

This changed attitude made itself felt on the catwalk, too; McQueen exercised restraint and held back from extravagant staging when he presented the clothing for his spring-summer 2005 collection. Lee loved to play chess and so he called his next show, appropriately, 'It's Only a Game'. The choreography paid complement to the chess match in the 'Harry Potter and the Philosopher's Stone' film.

This was a pandora's box of a show in which McQueen revisited some of his former pieces refashioned under the theme of another film, 'Picnic at Hanging Rock'. He allowed his fantasy to roam using models from a variety of cultures to emphasise his clothes, achieving one of the most beautiful shows in his short career. The look was determinedly youthful, the models wearing puffed and coiled hair; the schoolgirl, the criss-cross bodice and the kimono reappeared in reworked form in a gorgeous variety of above-the-knee skirts (the delicious, panniered-style dress was a highlight, shell pink with an underbody in saturated colours and Japanese embroidery, the model bearing an exquisite and delicate, carved crown) and dresses, as the models filled the runway. The finalé was a chess game in which the models slowly dismissed one another from a board that was created by lighting. Once

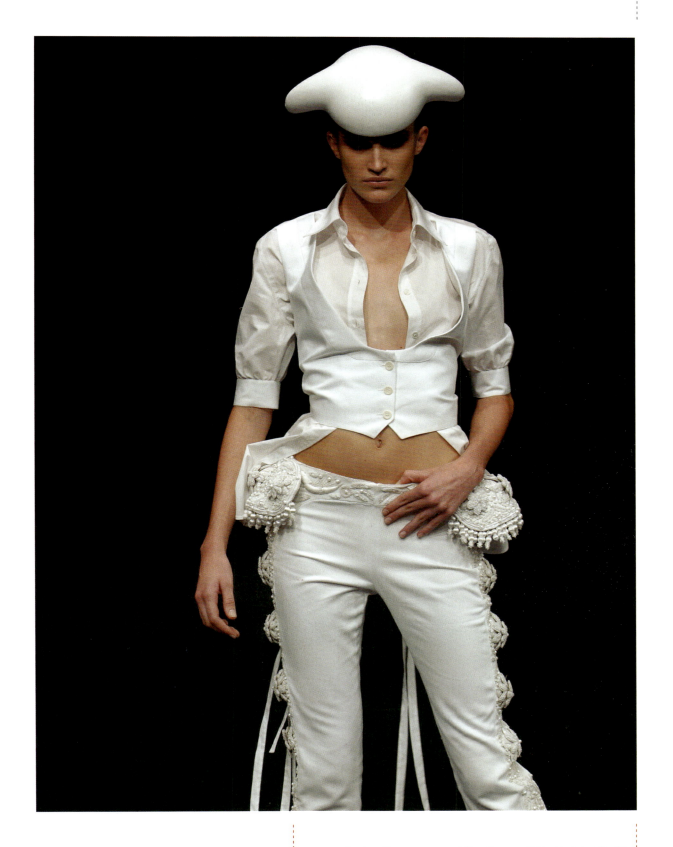

ABOVE: Spring/Summer 2002 "The Dance of The Twisted Bull"

again, the brightness and glitter was marbled with a sense of threat, a sense of all not being what it seemed. This was a theme that McQueen felt ran in parallel with his own life where no one saw the strains placed upon him – the word he used was *"trauma"* – but thought they knew him because of the glamorous twenty minutes of a catwalk show. In the words of Shakespeare, *"All that glitters is not gold … gilded tombs do worms enfold"*.

As the Gucci juggernaut rolled onwards with McQueen at the wheel, the autumn-winter 2005–06 collection was presented; "The Man Who Knew Too Much". This was the name of a film directed by Sir Alfred Hitchcock, who also made the film "Vertigo" in which the actress Kim Novak appeared. McQueen made the slim connection in his new collection by creating the "Novak" bag. It was made in forest green of mock crocodile skin. It became one of his most popular items.

In a Parisian school hall flooded with red light and peopled with red-lipped models, who this time walked along a more conventional runway, McQueen displayed pencil skirts, funnel-shaped ball gowns, chunky mohair, trench coats, jeans wear and swing skirts. Nothing to frighten the horses, clothing in browns and silver and white. Despite referencing the film look from the movies of the fifties, some of the combinations were almost drab and plain, certainly by McQueen's standards, almost as though he had been instructed to aim at the well-heeled older client. Wearable items, in fact. Something that an earlier McQueen could not have countenanced. The collection satisfied one half of the Gucci/McQueen tandem; it turned out to be his greatest commercial success. It is tempting to suggest that McQueen's comment on this collection was his failure to appear for the applause at the end. It is not too far-fetched to suggest that what was going on in his head at the time was a dangerous, explosive, emotionally-charged mix.

McQueen and Blow were no longer on speaking terms; this rift was initiated by McQueen because of Isabella's reconciliation with her husband. He had also wearied of giving his dresses to her and never seeing them again. For her part, she was resentful because he made her wait for his newest creations.

The super model Kate Moss was embroiled in a drug scandal, having been, allegedly, caught snorting cocaine, a drug which most of the fashion world, the media world and therefore most of the people around her were also indulging in. We know you do it but if you get caught you are on your own was the understanding. Chanel and H&M, fearful for their clean images, dropped her from their advertising campaigns.

As for McQueen, he seemed to be losing, or had been forced

ABOVE AND RIGHT: Spring/Summer 2002 "The Dance of The Twisted Bull"

to blunt the edge that had made him a household name, and his next show, 'Neptune', for spring-summer 2006, was a *"let down"*, to quote one fashion magazine. Presented in a warehouse on a 30ft catwalk, McQueen cited other designers as his inspiration for the 'power girls' in his programme.

It was blatantly obvious in its intent, with models of 5'11" in very high heels and scantily clad ... the message was sex as power. But McQueen seemed to have lost the incisiveness in his message and the clothes appeared to cater to a one-dimensional, pandered, trendy girl swanning about in the world of the wealthy; as though this look attached to height alone qualified the wearer for a strong woman award. It was a power girl seen through a McQueen squint rather than a reality. McQueen had certainly diluted his innovative devilment; commercialism was alive and kicking in 'Neptune' and probably mocking McQueen at the same time. He dipped his hand into swimwear this time and referred to ancient Greece in his styles for the female goddesses on the catwalk. Leggy girls, naked breasts, sexy short tunics and gold emphasised this aspect of his show which ran the risk of sliding into kitsch.

Ink black dominated the initial phase of the collection with figure-hugging and feminine soft fabrics that looked gorgeous. A brief white phase followed, long, slit to the upper thigh dresses giving way to gold and greens and a second swimsuit in intertwined coils over naked breasts. It was not what McQueen had primed his audience to expect from him; minimalism. That was perhaps the only unusual aspect to a deliciously tailored but unspectacular show.

McQueen appeared at the end, to advertise his support for the 'disgraced' Kate Moss by running down the length of the catwalk wearing a t-shirt emblazoned with the words, "WE LOVE YOU KATE", before retiring as swiftly as he had come. It was a brave and touching gesture and typical of the strong loyalty he was capable of expressing.

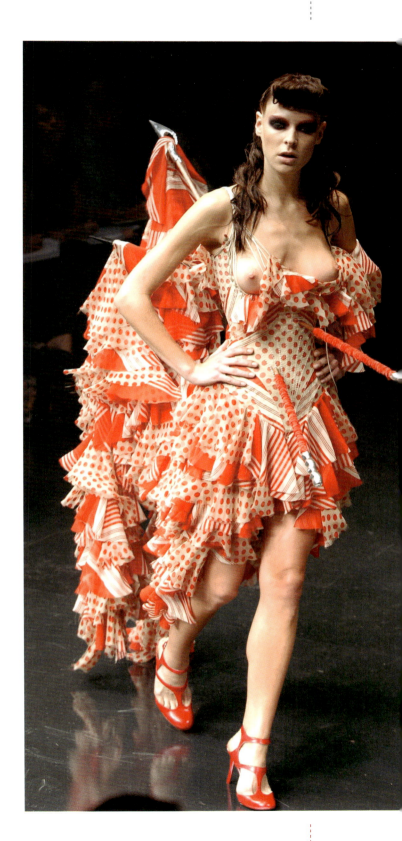

THE FASHION ICONS — McQUEEN

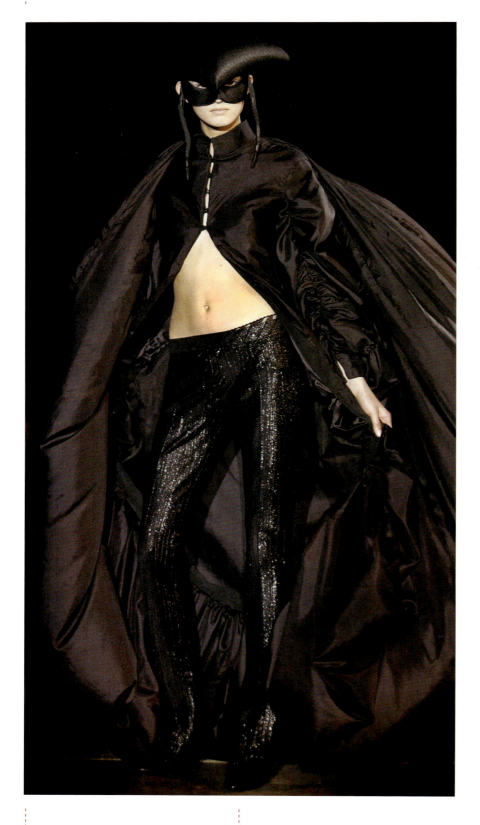

ABOVE AND RIGHT: Autumn/Winter 2002
"Supercalifragilisticexpialidocious"

UNBOUNDED FAME 2001-2006

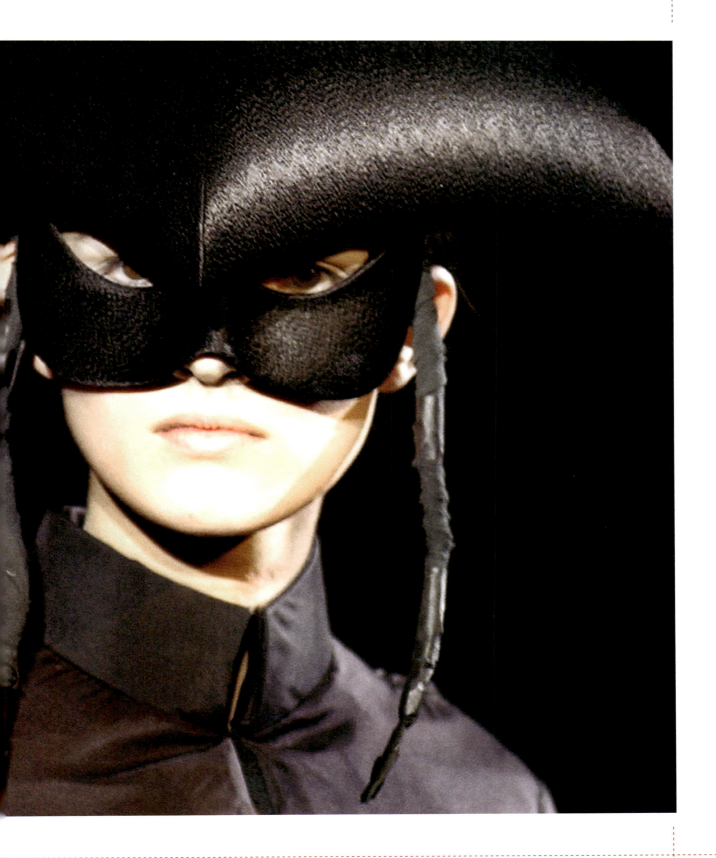

THE FASHION ICONS McQUEEN

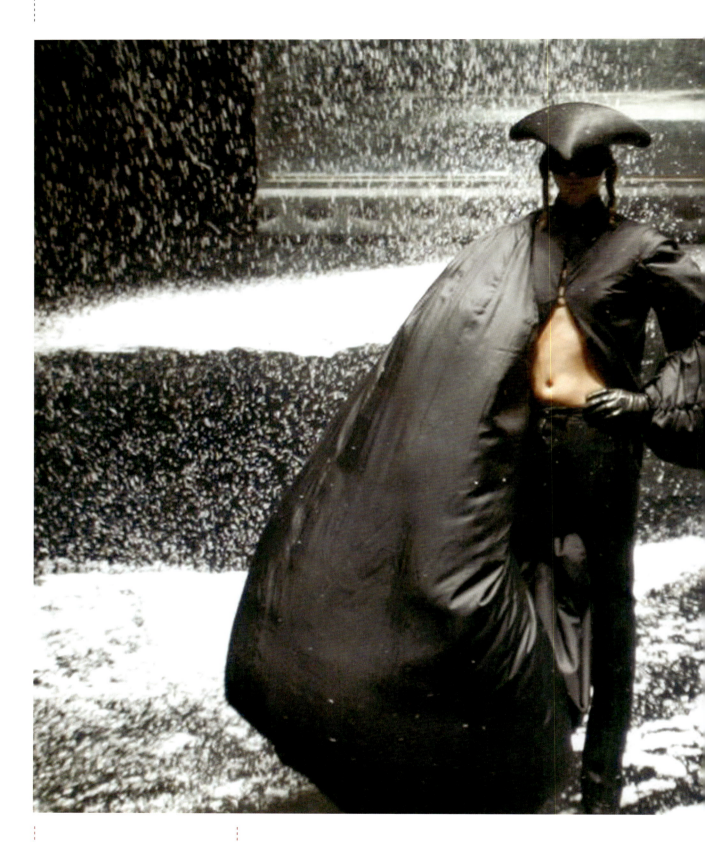

ABOVE: Autumn/Winter 2002
"Supercalifragilisticexpialidocious"

UNBOUNDED FAME 2001-2006

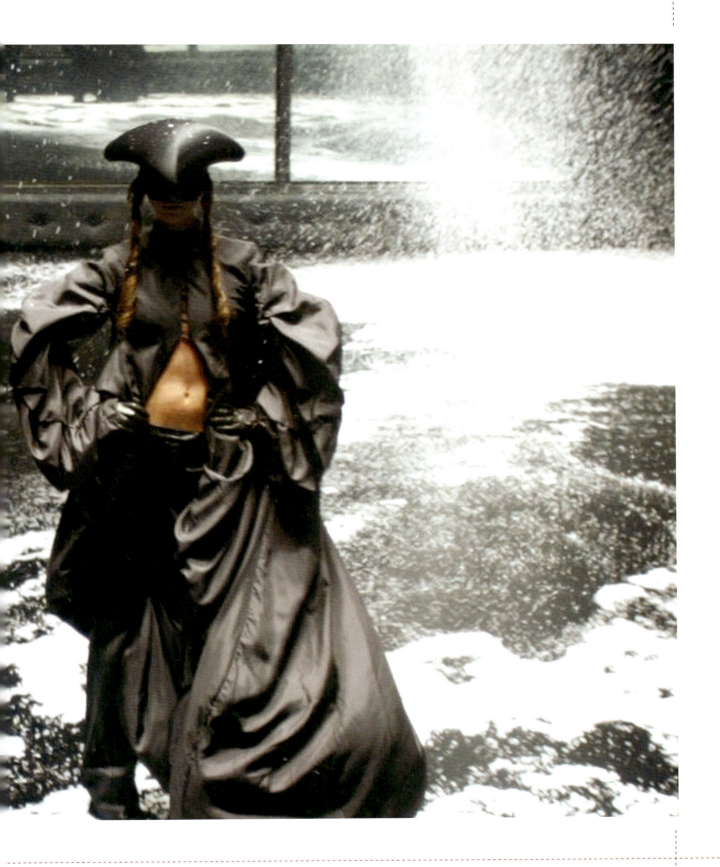

THE FASHION ICONS McQUEEN

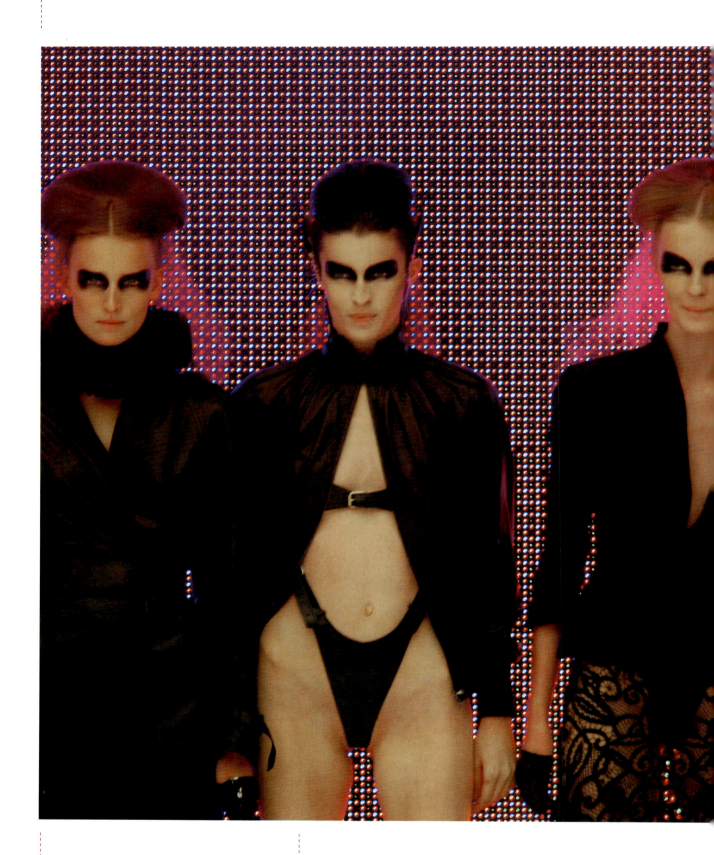

ABOVE AND RIGHT: Spring/Summer 2003 "Irere"

UNBOUNDED FAME 2001-2006

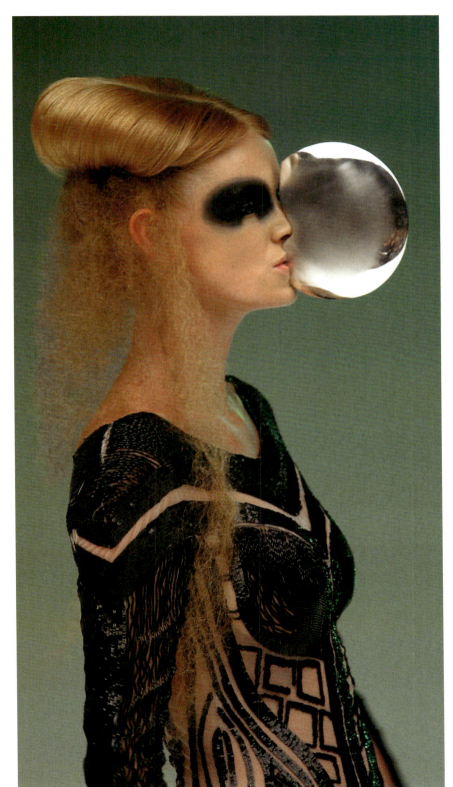

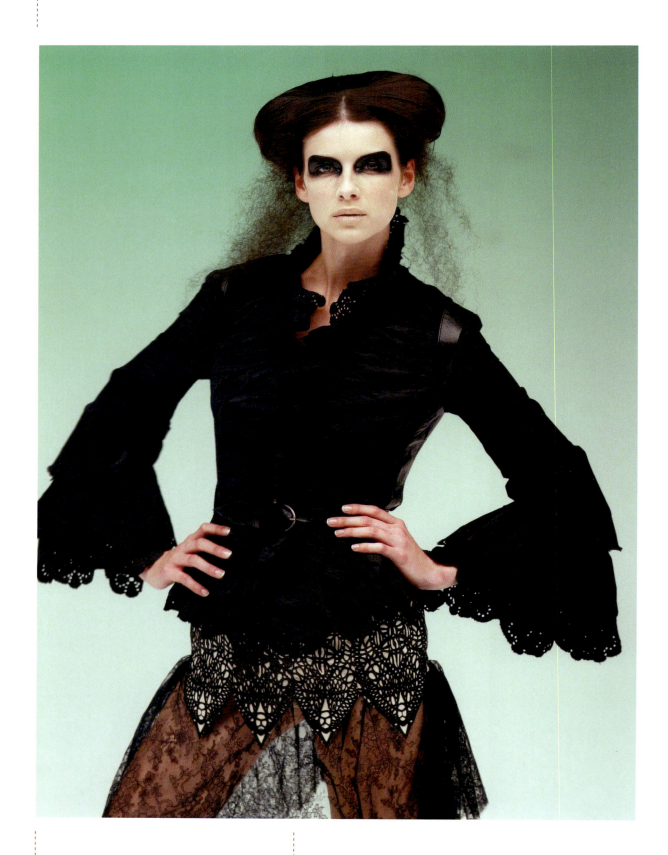

ABOVE AND RIGHT: Spring/Summer 2003 "Irere"

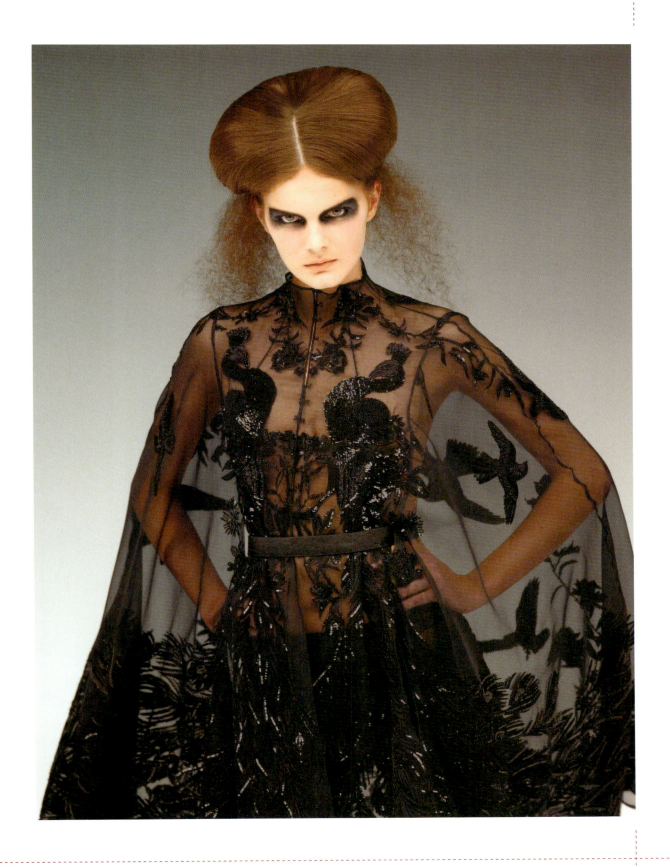

THE FASHION ICONS McQUEEN

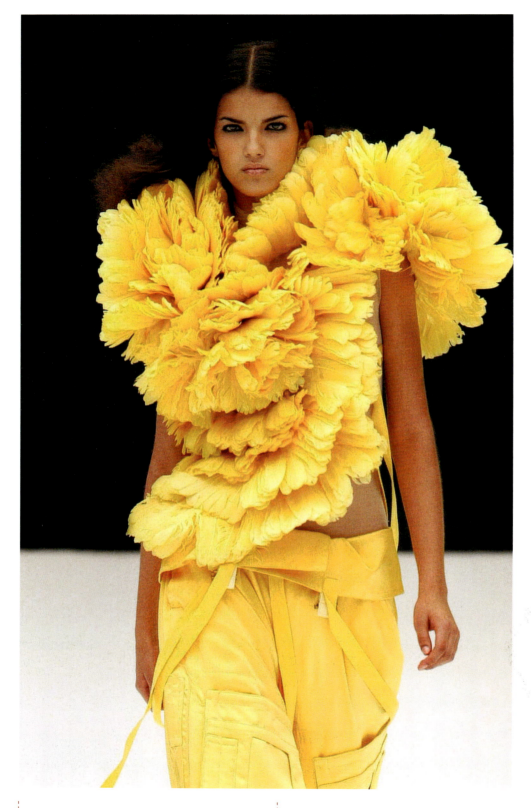

ABOVE AND RIGHT: Spring/Summer 2003 "Irere"

UNBOUNDED FAME 2001-2006

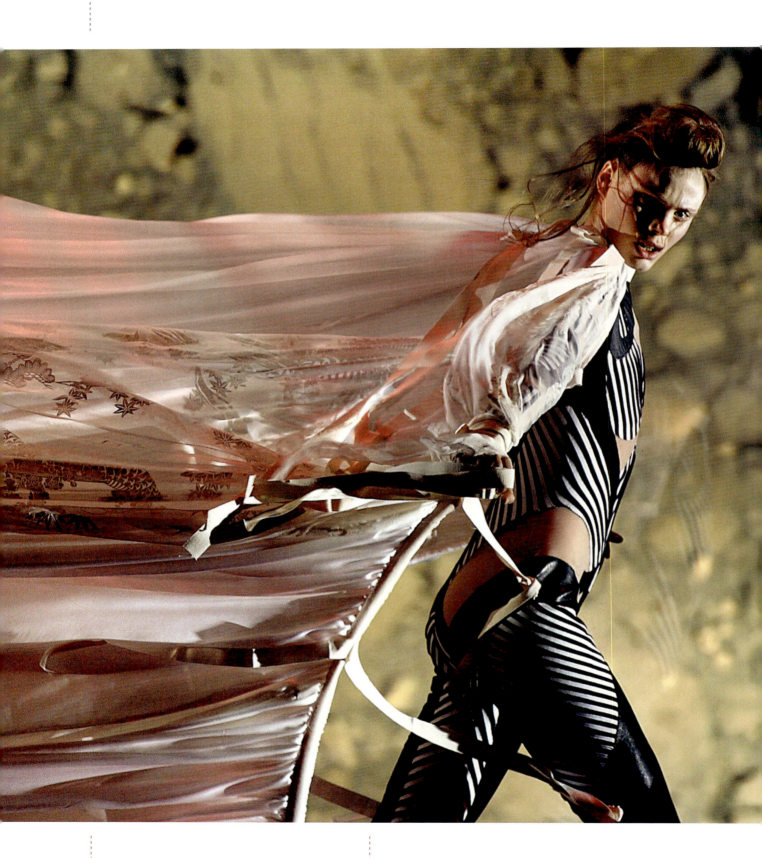

ABOVE AND RIGHT: Autumn/Winter 2003 "Scanners"

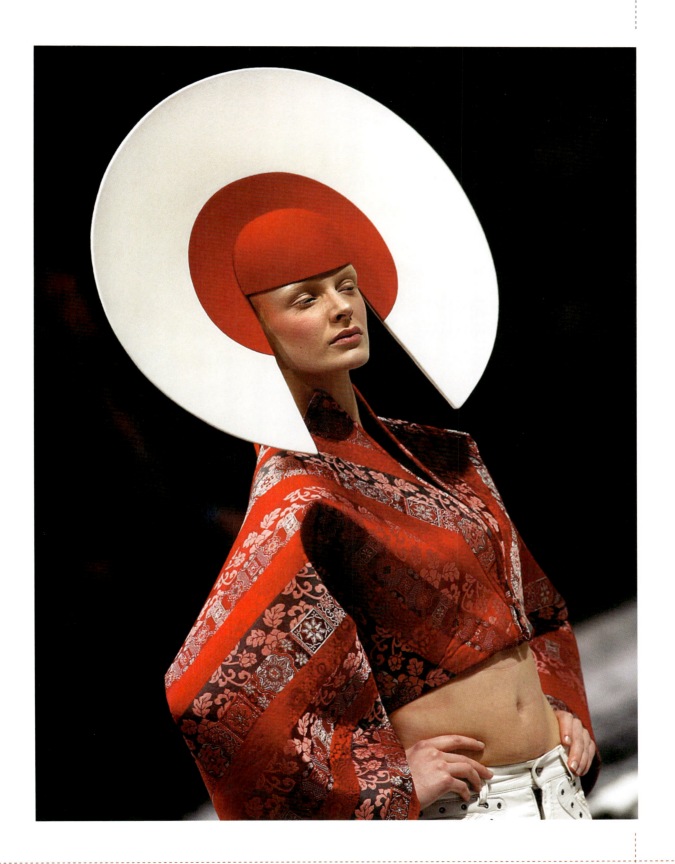

THE FASHION ICONS McQUEEN

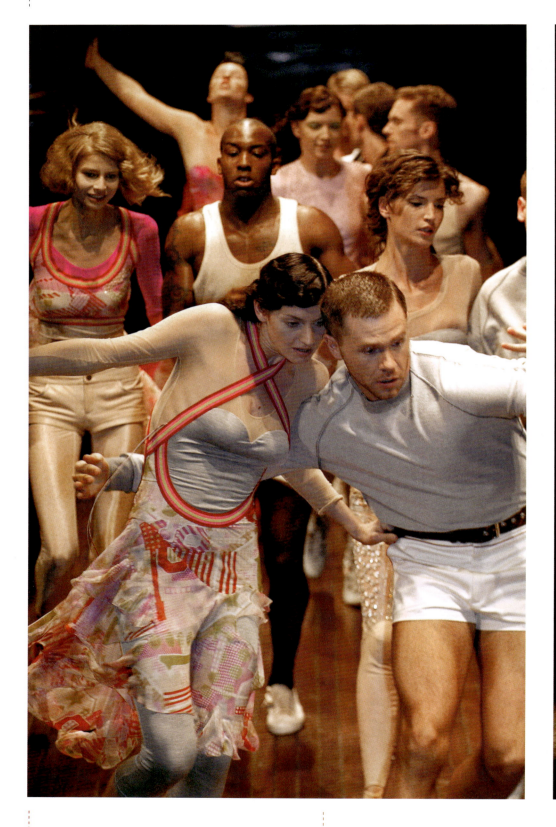
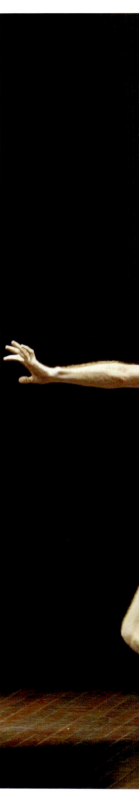

ABOVE AND RIGHT: Spring/Summer 2004 "Deliverance"

UNBOUNDED FAME 2001-2006

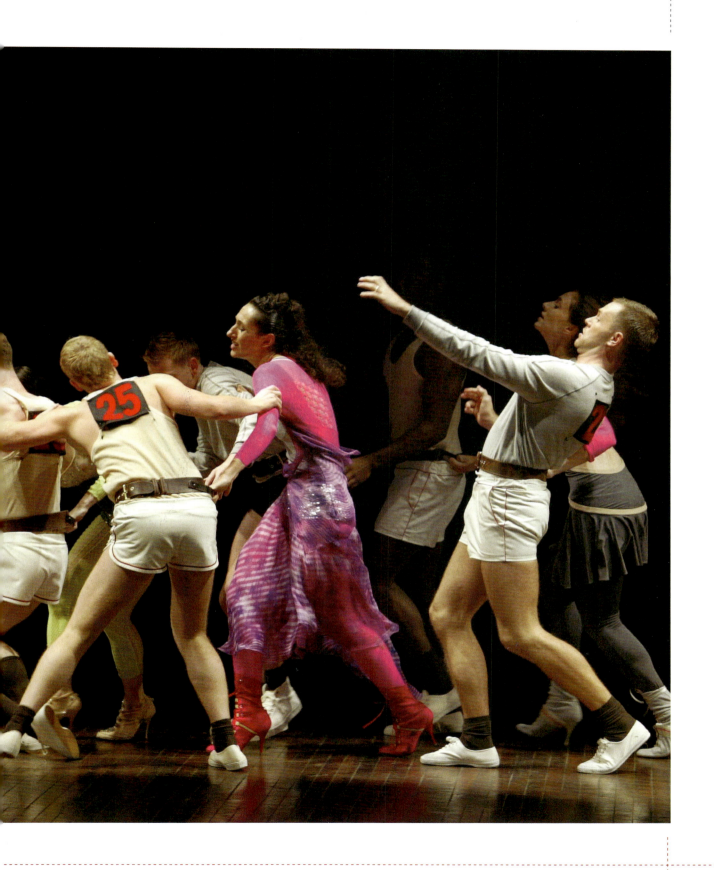

THE FASHION ICONS McQUEEN

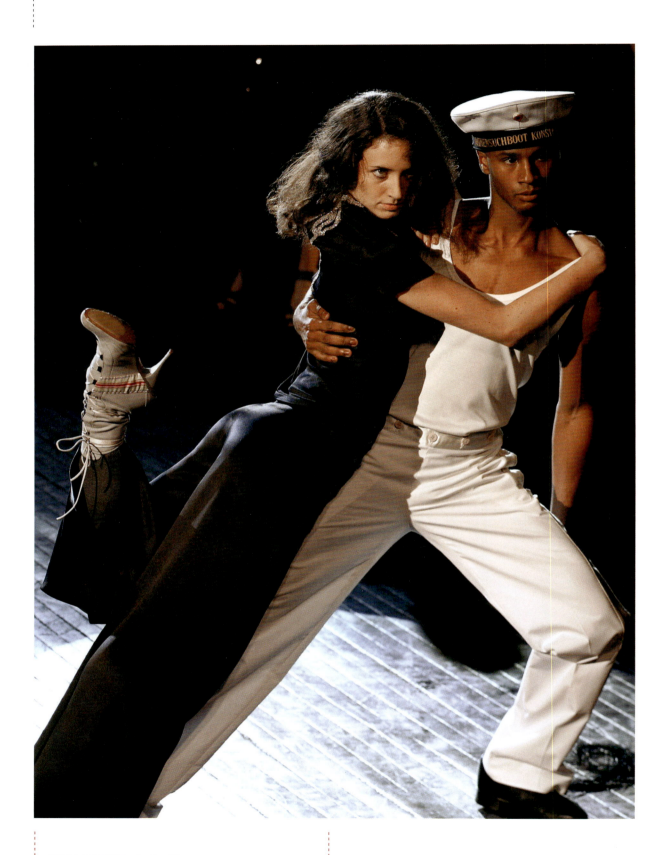

ABOVE AND RIGHT: Spring/Summer 2004 "Deliverance"

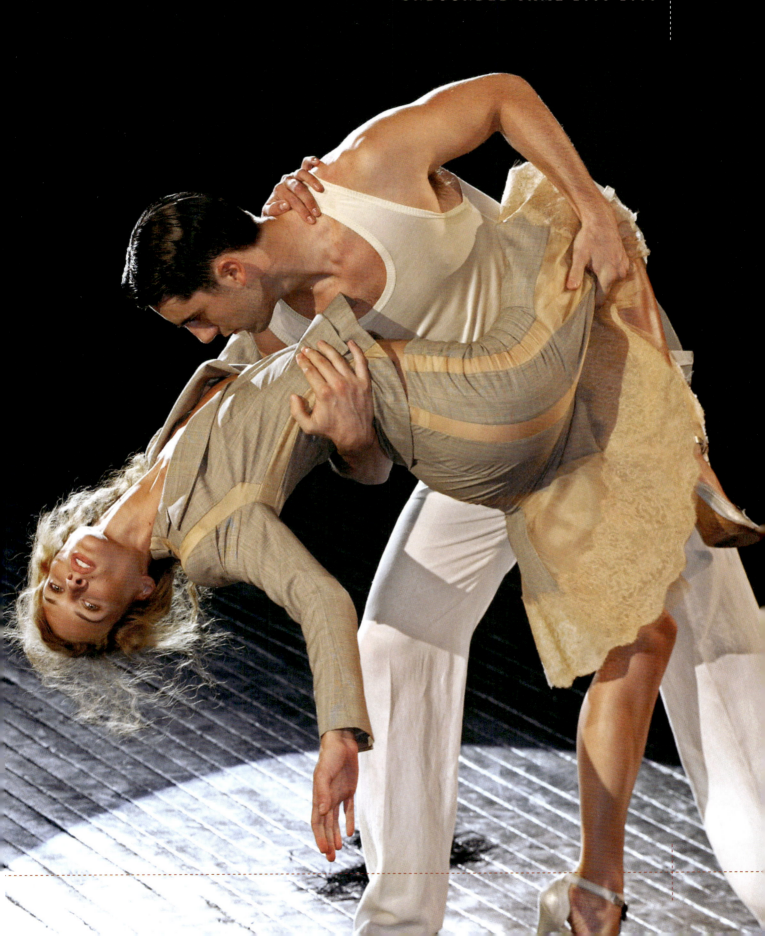

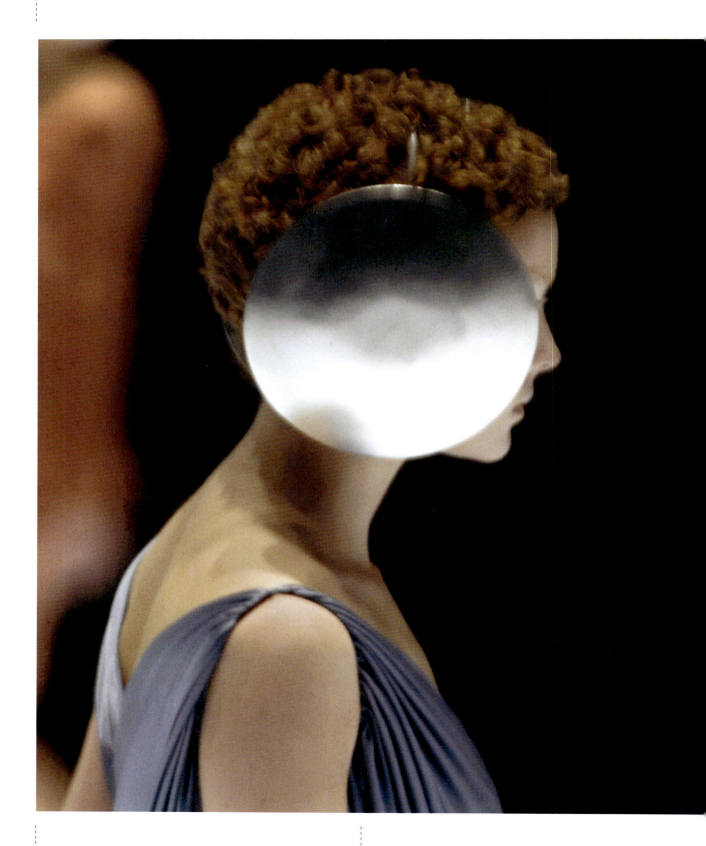

ABOVE AND RIGHT: Autumn/Winter 2004 "Pantheon as Lecum"

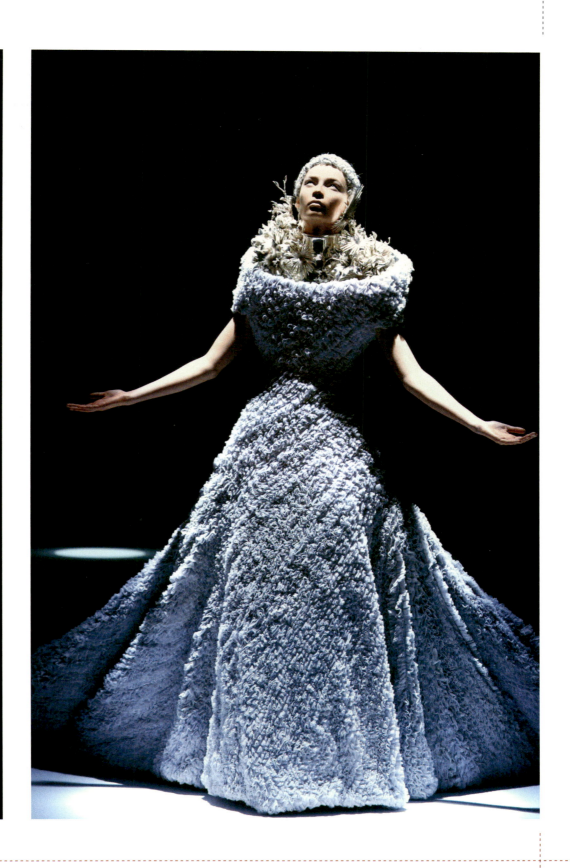

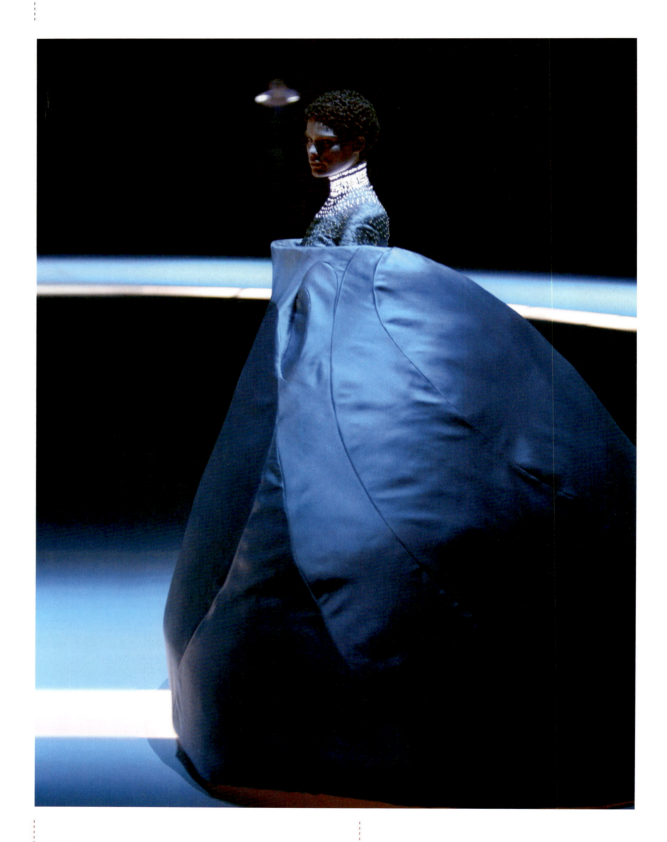

ABOVE AND RIGHT: Autumn/Winter 2004 "Pantheon as Lecum"

UNBOUNDED FAME 2001-2006

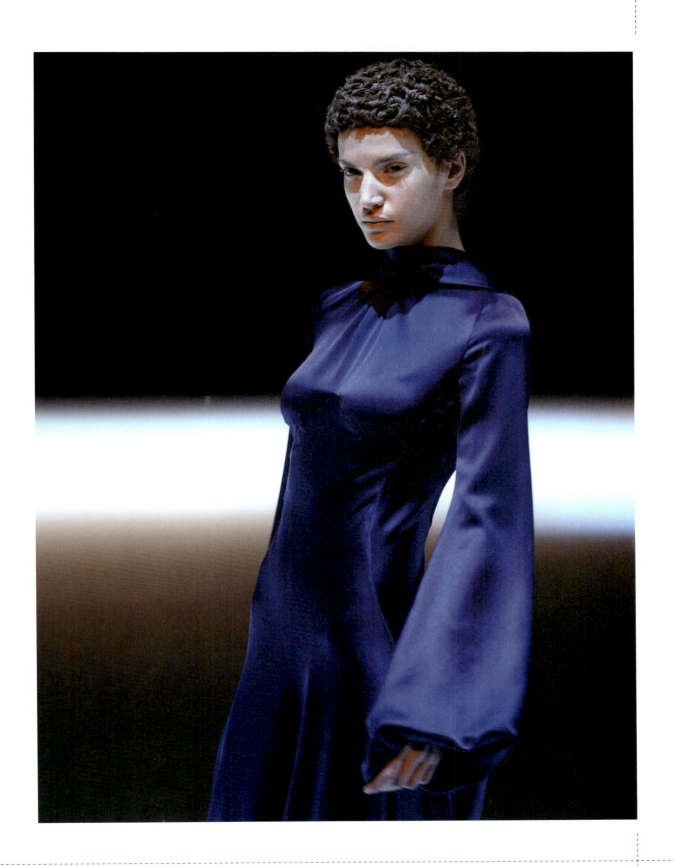

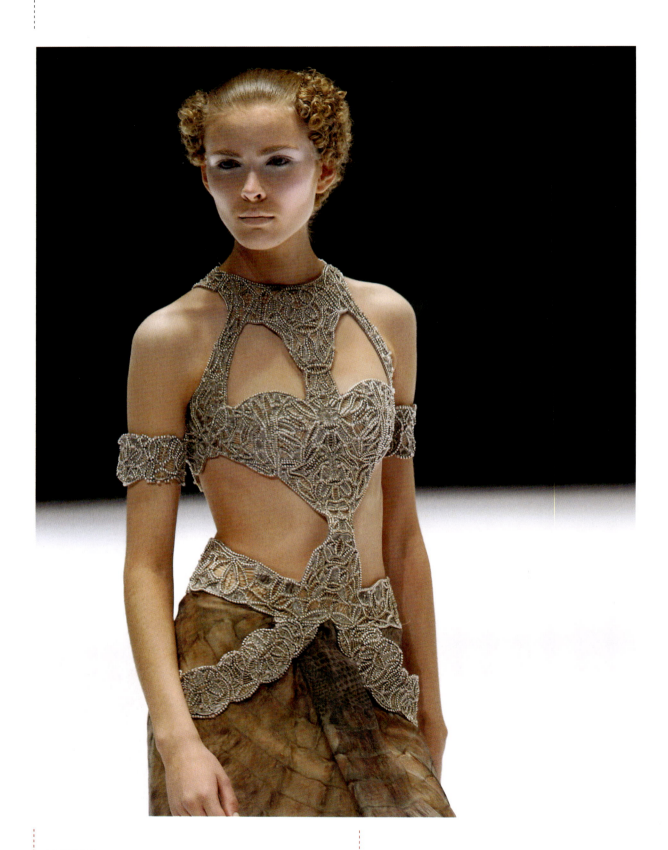

ABOVE AND RIGHT: Autumn/Winter 2004 "Pantheon as Lecum"

UNBOUNDED FAME 2001-2006

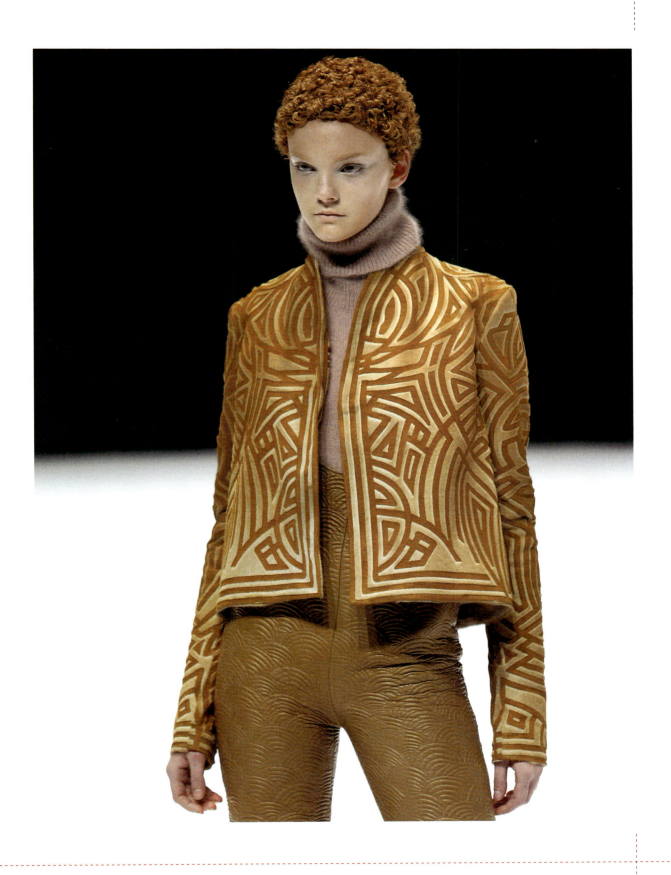

THE FASHION ICONS McQUEEN

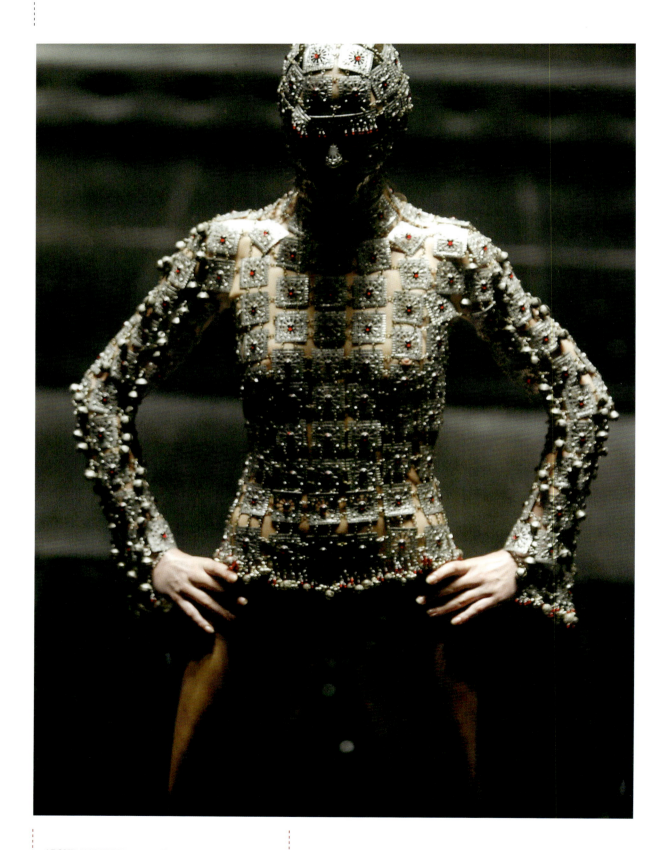

ABOVE AND RIGHT: 2004 "Black" One night only retrospective of his work

UNBOUNDED FAME 2001-2006

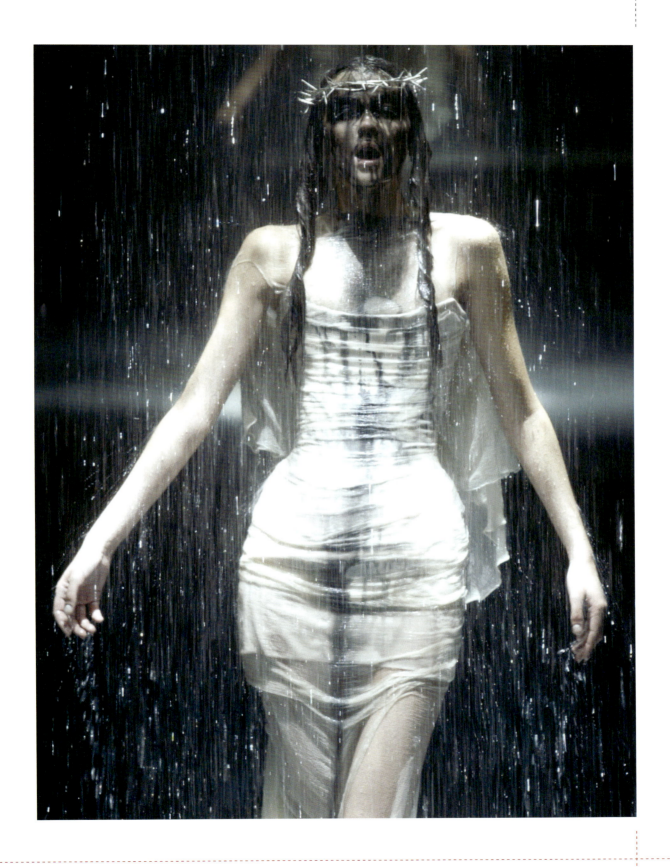

THE FASHION ICONS McQUEEN

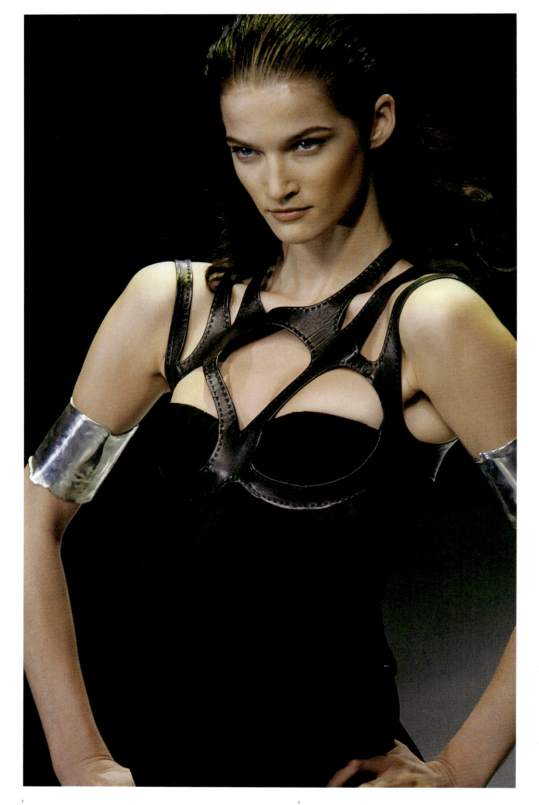

ABOVE AND RIGHT: Spring/Summer 2006 "Neptune"

UNBOUNDED FAME 2001-2006

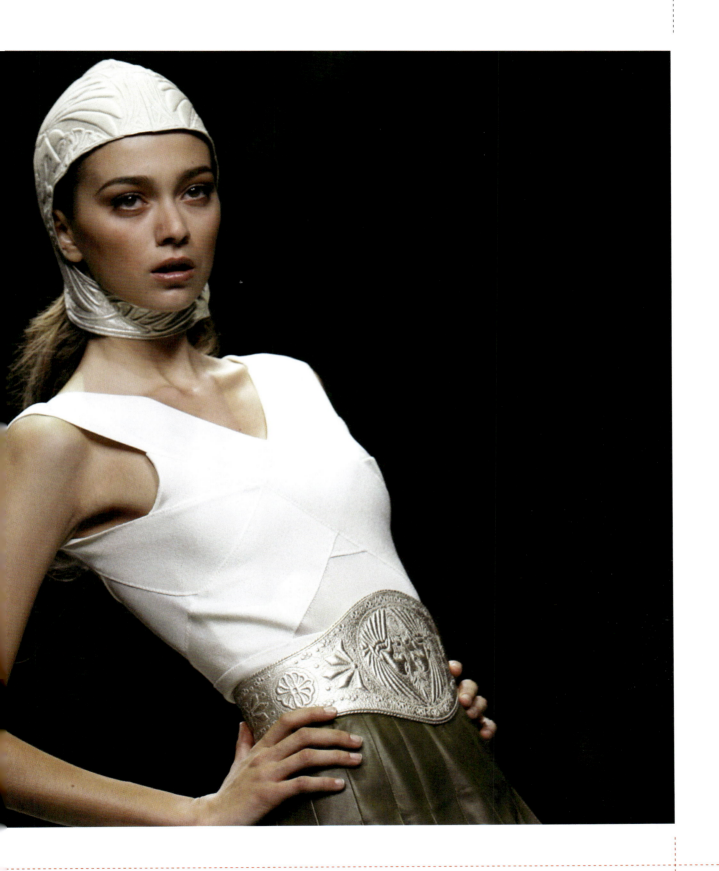

GLAMOUR AND PAIN 2006-2010

"I suppose I am a very melancholy person."

After several uncharacteristic McQueen collections, rumours were bubbling to the surface that the enfant terrible had become a former enfant terrible, a shadow of the earlier designer. McQueen felt this himself and was determined to get the upper hand in the struggle between the commercial master and the imaginative-creative servant. The result was a return to Scotland for the autumn-winter collection of 2006/07, "The Widows of Culloden". The Battle of Culloden was fought in April 1746 between Bonnie Prince Charlie and his troops led by Lord Murray, and the Duke of Cumberland, son of King George II.

The show harked back to McQueen's early days when he was firing sartorial and verbal brickbats at the world in "Highland Rape". But now, he was a different man. He had learned lessons and gained experiences. He had grown up and although he was still bedeviled by his neuroses, they were tempered when manifested in his work, by his creative ethics towards design and his desire to be as honest as he could to himself and to women. The messages could be all the more powerful now that they were clothed in sophistication. The result was a critically lauded show presented without background hysterics.

His "WE LOVE YOU KATE" message was expanded and not only was the collection dedicated to her (or Isabella Blow or the widows of Culloden depending on who is to be believed), she featured in "The Widows", as the spectacular finalé.

McQueen's expressed desire was for the collection to emphasise, by exaggerating female curves, a silhouette that would draw parallels to the statues of classical antiquity. Nipped waists, bustles and rounded hip lines were used to achieve the effect, as were ornate brocades, embroidered tulles, ruffs, sumptuous velvets and, of course, tartan. The idea, heightened by the sartorial references to the past, was to create an atmosphere of romantic melancholia underpinned by the dark undertones of the show's theme. Each piece of clothing was carefully crafted as though it were intended to be a family heirloom for generations to come. Each piece intended to draw attention to the female form in a variety of ways from explosive to refined. Earth colours in rich browns and golden greens kept the first section of the show firmly rooted in its concept, as did a military-style jacket and the heavy furs. A parade of tartans followed, contoured in a variety of ways from jacket to dress.

McQueen's symbols were back on display; antler and bird headpieces and feathers. His Savile Row roots were acknowledged in sharp suits and jackets.

There was beautiful tailoring in the softness of the long dresses that roamed between sleek and fountains of ruffles. But he saved the best until last. The dress underlining the fact that death had severed the Culloden women from their earlier innocent happiness was a magnificent, floor-length bridal gown of lace shedding a waterfall of ruffles.

And then came his pièce de résistance; a hologram of Kate

GLAMOUR AND PAIN 2006-2010

Moss floating eerily and languidly in space, turning amidst a cloud of fluttering chiffon to the emotive melody from Schindler's List, a melody that recalled the lost souls of the Scottish uprisings and violent oppression everywhere. As Kate Moss slowly materialised and dematerialised, herself a lost soul, no one remained unaffected by this beautiful, defiant and imaginative flight of fantasy. With this confrontational move of hiring Moss, McQueen virtually flipped the bird in the face of the status quo and what he perceived to be its egregious, hypocritical social repression. It was a moment of magic on many levels.

"As a designer, you've always got to push yourself forwards", said McQueen, and he kept up with the leaders by delving into the past with his next show, which zig-zagged through the centuries acknowledging influences from the film Barry Lyndon, Goya, and the socialite Marchesa Luisa Casati. Handel's Sarabande music played by a live orchestra provided the springboard for the theme.

Staged in the round in Paris at the Cirque d'Hiver with the puffball-haired models walking sedately instead of assertively, Sarabande was the spring summer 2006/07 collection created by McQueen in a *"darkly romantic"* mood, in his own words. As he associated romanticism with submerged aggression, we may speculate about his state of mind during what was probably his most romantic show. Being under pressure to at least break even and needing to sell as well as remain contemporary and unique no doubt added to the 'darkness' in the realm inside his head.

McQueen could never bring himself to see the world as purely romantic, so harshness can be seen in the sculpted forms that framed some of his most beautiful creations, such as the stunning flower gown, that by itself contained countless hours of needlework.

A giant candelabra rose from the floor to open the show. Slim,

feminine, ruched gowns and trouser suits decorated with ruffs, feathers and bows came in interchanging creams, whites and blacks in the initial section of the collection. This was McQueen selling his tailoring skill for a wide range of tastes, with long, full gowns predominating.

A few contours were introduced that ballooned around the hips and shoulders hiding the form of the model; shape-shifting, something McQueen liked to do; but for the most part he kept to the commercial script in this collection.

Briefly, he accentuated the flower theme that had been lightly touched on; it culminated in a gorgeous head-to-toe flower dress. Hand-painted birds and puffed hems, black ostrich feathers and silk petals rounded out the sumptuousness of the final pieces.

McQueen entered the new year of 2007 unaware that it was to prove a turning point in his life. He had, in fact, entered the final act of a performance that embroiled and tangled his own reality with his work, inseparable elements in his life. And one of the pillars of that performance was about to come crashing down and almost as surely as night follows day, take McQueen with it.

It was ironic, therefore, that he chose for his autumn winter 2007/08 collection the theme of death and injustice to a woman.

Lee had found out that there was a distant relationship between the McQueen family and the Howe family of Massachusetts in the USA. Elizabeth Howe had been the innocent victim of the witch hunt hysteria in New England in 1692, accused by a ten-year-old girl and her parents of afflicting the youngster with illness. Elizabeth was tried, found guilty and hanged. The British designer visited the grave. It was a macabre story and right up McQueen's street, as the London boy might have said himself; a historical, personal theme, gothically sinister, with male violence, bigotry and persecution as it's central thread and death thrown in for good measure.

So 'In Memory of Elizabeth Howe, Salem, 1692' was born, a sartorial investigation of the supernatural and the pagan roots of superstition. Parallel to witch hunting, McQueen had also discovered ancient Egypt as a source of inspiration, and the show therefore embodied elements of Egyptian deity worship; an inverted black pyramid hung over the runway. A pentagram – a symbol for the ancient Egyptians (amongst many others) which originally meant 'heavenly body', but which, when inverted, was used by satanists to indicate evil – of blood-red crystal was inlaid into the floor of the runway. There was very little lighting, so that it was hard to distinguish the clothes in the gloom, which re-enforced the darkness of his theme. On a video screen, naked girls floated as though in a womb. Outside in the street, an atmospheric, heavy rainstorm thrashed the sports stadium with the models and their Cleopatra-look make up inside.

McQueen took the rigidity of the Egyptian sarcophagus and mummy and transposed them to his clothes; the show began with a variety of stiff, short skirts alternating with high boots and tights in blacks and sand colours before shining greens, blues and golds arrived with delicious imitation ancient patterning. There was very little movement in the clothes, the models encased in their fabrics, until a shimmering gold, sleeveless full-length gown appeared. More distinctly eastern was the skintight gold of the next model in breastplate and a metallic unitard covered in pailettes that made her resemble a living statuette. Following this sumptuous exhibition of the female form, a veiled face, a series of headscarves, a moulded body case and a mask established a courageous connection to female subjugation. Mini skirts and short dresses then returned in furs and as a blood-red explosion over the hips.

A series of black and olive green dresses and jackets ushered in flowing silver and black dresses glittering in the light which

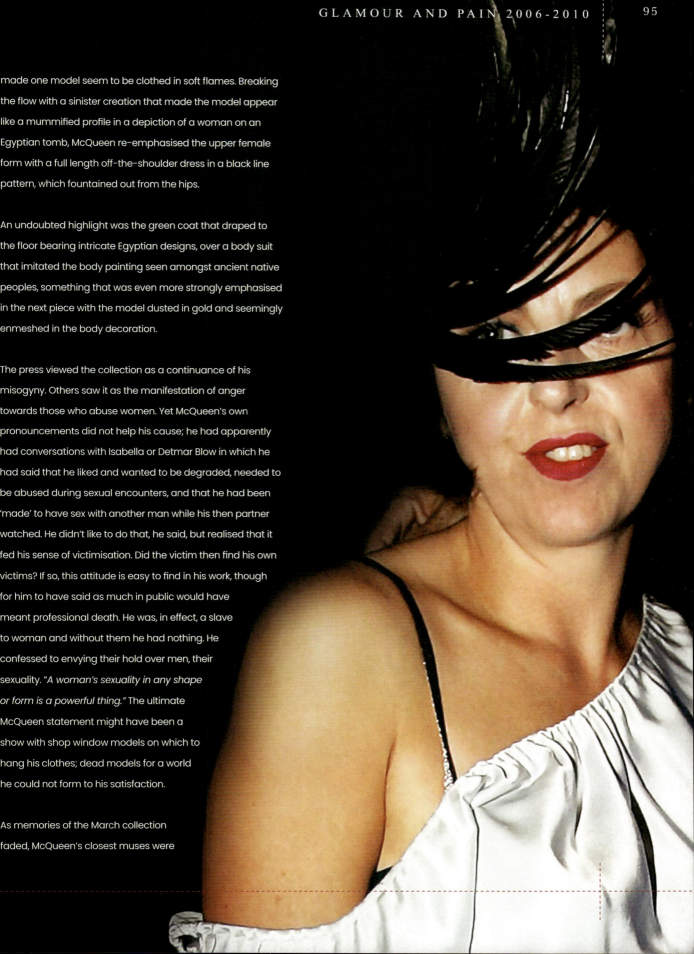

made one model seem to be clothed in soft flames. Breaking the flow with a sinister creation that made the model appear like a mummified profile in a depiction of a woman on an Egyptian tomb, McQueen re-emphasised the upper female form with a full length off-the-shoulder dress in a black line pattern, which fountained out from the hips.

An undoubted highlight was the green coat that draped to the floor bearing intricate Egyptian designs, over a body suit that imitated the body painting seen amongst ancient native peoples, something that was even more strongly emphasised in the next piece with the model dusted in gold and seemingly enmeshed in the body decoration.

The press viewed the collection as a continuance of his misogyny. Others saw it as the manifestation of anger towards those who abuse women. Yet McQueen's own pronouncements did not help his cause; he had apparently had conversations with Isabella or Detmar Blow in which he had said that he liked and wanted to be degraded, needed to be abused during sexual encounters, and that he had been 'made' to have sex with another man while his then partner watched. He didn't like to do that, he said, but realised that it fed his sense of victimisation. Did the victim then find his own victims? If so, this attitude is easy to find in his work, though for him to have said as much in public would have meant professional death. He was, in effect, a slave to woman and without them he had nothing. He confessed to envying their hold over men, their sexuality. *"A woman's sexuality in any shape or form is a powerful thing."* The ultimate McQueen statement might have been a show with shop window models on which to hang his clothes; dead models for a world he could not form to his satisfaction.

As memories of the March collection faded, McQueen's closest muses were

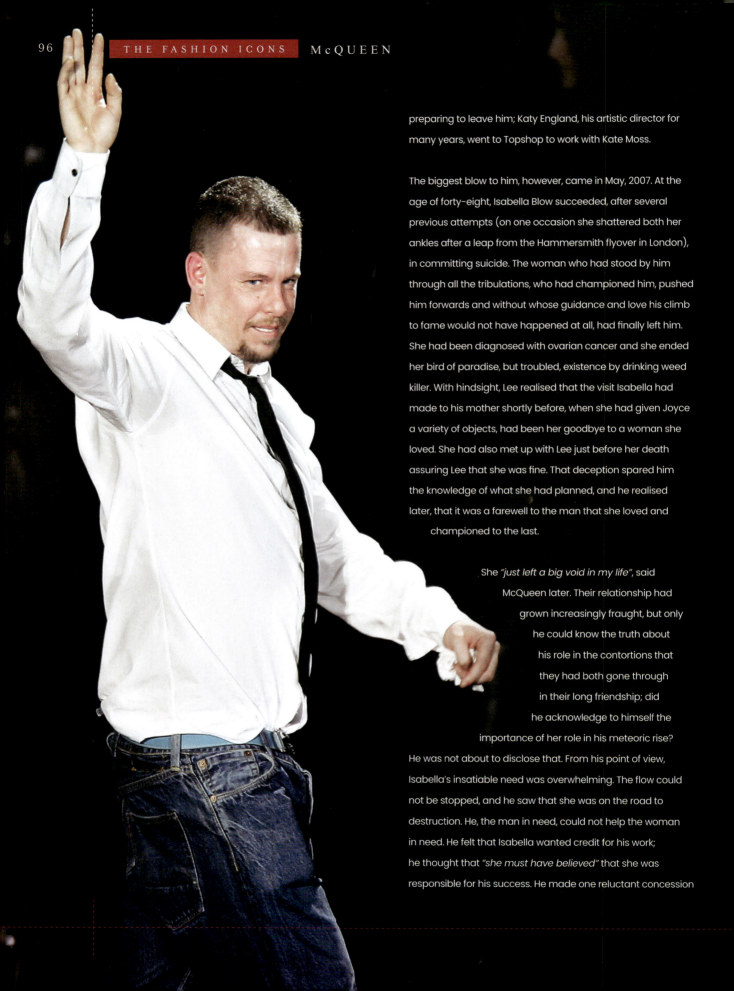

preparing to leave him; Katy England, his artistic director for many years, went to Topshop to work with Kate Moss.

The biggest blow to him, however, came in May, 2007. At the age of forty-eight, Isabella Blow succeeded, after several previous attempts (on one occasion she shattered both her ankles after a leap from the Hammersmith flyover in London), in committing suicide. The woman who had stood by him through all the tribulations, who had championed him, pushed him forwards and without whose guidance and love his climb to fame would not have happened at all, had finally left him. She had been diagnosed with ovarian cancer and she ended her bird of paradise, but troubled, existence by drinking weed killer. With hindsight, Lee realised that the visit Isabella had made to his mother shortly before, when she had given Joyce a variety of objects, had been her goodbye to a woman she loved. She had also met up with Lee just before her death assuring Lee that she was fine. That deception spared him the knowledge of what she had planned, and he realised later, that it was a farewell to the man that she loved and championed to the last.

She *"just left a big void in my life"*, said McQueen later. Their relationship had grown increasingly fraught, but only he could know the truth about his role in the contortions that they had both gone through in their long friendship; did he acknowledge to himself the importance of her role in his meteoric rise? He was not about to disclose that. From his point of view, Isabella's insatiable need was overwhelming. The flow could not be stopped, and he saw that she was on the road to destruction. He, the man in need, could not help the woman in need. He felt that Isabella wanted credit for his work; he thought that *"she must have believed"* that she was responsible for his success. He made one reluctant concession

on that score; *"in some ways she is"*, he said; but it was only *"for finding me"*. It is known, however, that Isabella said, *"The role of a muse is changing. If Alexander uses some of my ideas in his show, and he has, I don't get paid; he does."*

He felt irritated by the accusations that Isabella had shoe-horned him into the job at Givenchy when he felt that he had prepared his own groundwork, and by the implication that he was not a businessman in his own right. He was adamant that he alone was responsible for getting himself into Givenchy and into Gucci. But he dismissed talk of any rift between himself and Isabella. He was quoted as saying that people didn't know what they were talking about, because they didn't know him or Isabella. *"They don't know my relationship with Isabella. What I had with Isabella was completely dissociated from fashion, beyond fashion."* Perhaps this is wishful thinking weighted in his own favour, for no one likes to think of themselves as unjust. The designer Julien MacDonald, another of Issie's favoured ones, recalled that *"Lee wasn't the nicest person to her, but she loved his genius. He was so crazy. One minute he'd be a wonderful person, and the next he'd be telling people to piss off."* In MacDonald's version of events, Isabella had given more than generously to Lee when he was penniless and not only financially; she had given time and energy, and he could have added status, which comes with being accepted in the right social strata at Isabella's side. After he landed the job at Givenchy and when Isabella had nothing, Lee did not reciprocate. Quite the opposite; he *"shut her out"*.

McQueen attended her funeral but could not face the memorial service and the flood of very public attention from those purporting to know him and Isabella, so he stayed away.

It was fitting that Isabella Blow's two most illustrious protégés, McQueen and Philip Treacy, another close friend of hers, combined their talents to produce McQueen's spring-summer 2008 collection in her honour. It was entitled 'La Dame Bleu'; the show must go on even though Icarus falls from the sky.

Guests had been sent invitations that depicted Isabella in a McQueen dress and Philip Treacy headdress, on a horse-drawn carriage rising up to heaven. With Isabella's favourite Robert Piguet scent wafting through the air, McQueen presented a beautiful collection dedicated to the glamour, the eccentricity, the contradiction, the theatricality of the diva, the fiercely loyal and generous woman that was Isabella Blow.

The set was a light show of outstretched wings; symbolic of Isabella as the phoenix rising or the bird of paradise ready to depart. The models entered through the wings and paraded on a runway reflecting the changing light colours from behind them, so that from head on, they appeared to have sprouted wings.

McQueen ran through a whole panoramic rainbow of styles that referenced previous collections – notably the Japanese couture of his Givenchy days – and ranged from jackets, coats and suits tailored with Savile Row precision, to silk chiffon, python skin and sequined cocktail dresses. Feathers were not forgotten, of course, for the departed bird of summer, the woman who was responsible for his introduction to falconry; some of them were, appropriately, black, such as those atop a pale blue chiffon dress. Both Treacy and McQueen referenced Blow's love of nature with bird and butterfly prints. And Isabella Blow without hats would have been unthinkable; Treacy did her proud with, amongst others, a superb red butterfly hat of sculpted feathers.

Apart from a few Venetian mask-like exceptions, gone was the usual aggression and distorting makeup. Gone was the outrageous; this was Isabella Blow's moment, a belated tribute. Wonderfully sleek, light grey skirts punctuated with vivid reds started the show, the models bearing delicate, twig-like headpieces, before one of them entered displaying the surrealistic cloud of red butterflies over her head and face. Romantic light pinks and whites took over; a deliciously wispy dress, for example, the model's face adorned with appliqué

feathers, one nipple visible beneath its white swathes – a reference to Isabella Blow's own blithely devil-may-care attitude and the days when she would walk into the Vogue office similarly semi-attired. Romanticism was interspersed with angular, exaggerated shoulder lines that brought the strong female theme back into play.

Two simple dresses in pink and black became the best sellers of the show. The models walked side by side and wore fencing masks as they showed off these modern, clean lines.

Long elegant dresses in increasingly vibrant colours came next, set off with black in a gentle reference to Blow's see-saw personality and culminating in a gorgeous dress resembling tropical plumage with tie-dye printing and a high, feathered collar.

For the finalé, McQueen's pale palette re-emerged; a diamond-shaped, soft pink dress and a pale blue chiffon parachute dress with eagle feathers.

Most telling and touching of all was the Neil Diamond song to which the models defiléd along the catwalk at the end; *"You are the sun, I am the moon, You are the words, I am the tune, Play me".*

With the wisdom of hindsight, McQueen had now stepped into the firing line of his emotional turbulence. Isabella had broken the triumvirate she had forged and the damage proved to be irreparable.

To gain some distance from the events of the year, McQueen and jewellery designer Shaun Leane took a trip to India and found inspiration for another collection in its vivid colours and its history of British imperial, military rule. Leane spoke about them seeing *"... so much beauty and so much of the English empire"* there.

The title of McQueen's show, however, was given to him by the sight of an elm tree in his garden in Sussex. Daydreaming, he imagined a girl living in it's six-hundred-year-old branches, a girl who became a princess when she touched the earth and who was rescued by a prince. The tree image appeared in the centre of the runway swathed in grey silk tulle for his autumn-winter collection 2008/09, "The Girl Who Lived in the Tree". The two inspirational sources resulted in one of McQueen's most eye-catching collections and iconic dresses and what many considered to be his best show. The girl seemed almost a reflection of McQueen himself; initially stuck up in his tree, finally daring to descend to the light and colour and so freeing his spirit. And, indeed, he mentioned this himself: *"... it was time to come out of the darkness and into the light. It was kind of my life."*

Was he finally able to be himself now that Isabella was no longer around? McQueen said that he had *"... learned a lot from her death. I learned a lot about myself"*. Life was worth living he said, as though it were a revelation.
"... I'm just fighting against it, fighting against the establishment." Isabella, he added, *"loved fashion, and I love fashion, and I was just in denial."*

And the month-long trip to India had rekindled the joy of work and had given him renewed purpose. The enfant terrible had withdrawn a long time ago. McQueen gradually discovered that the truth in an idea that had some meaning to the world was more interesting than a vague, self-righteous need to shock as a means to proving the value of your existence.

The dichotomy of inspiration was reflected on the catwalk. There were two styles, one rather more sinister, more punk oriented and the other very clean, light, reminiscent of the age of Elizabeth 1st, with the Duke of Wellington coming along for the ride. In the phrase coined by Dennis Freedman, founding creative director of 'W' magazine, this was *"historicism modernised"*.

GLAMOUR AND PAIN 2006-2010

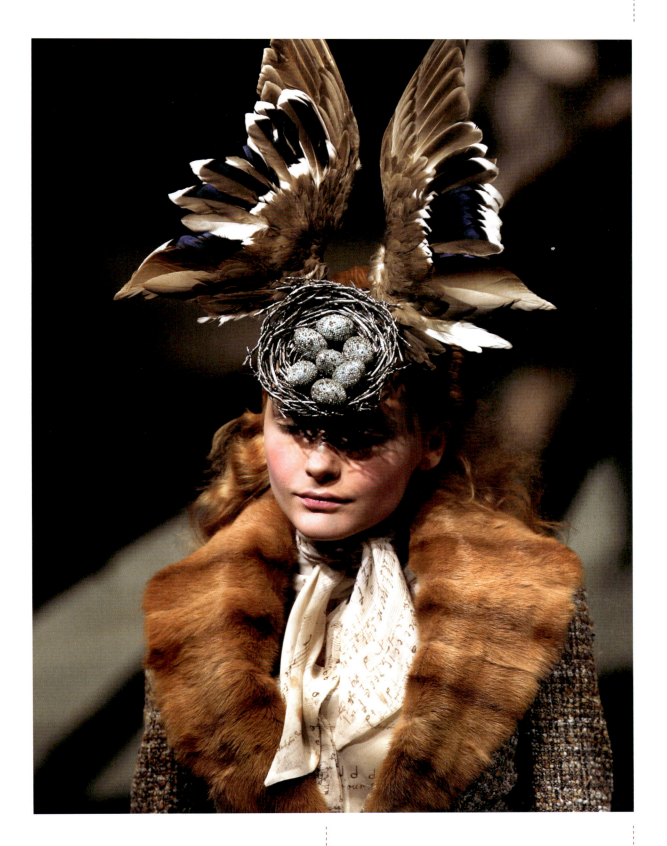

ABOVE: Autumn/Winter 2006 "The Widows of Culloden"

THE FASHION ICONS McQUEEN

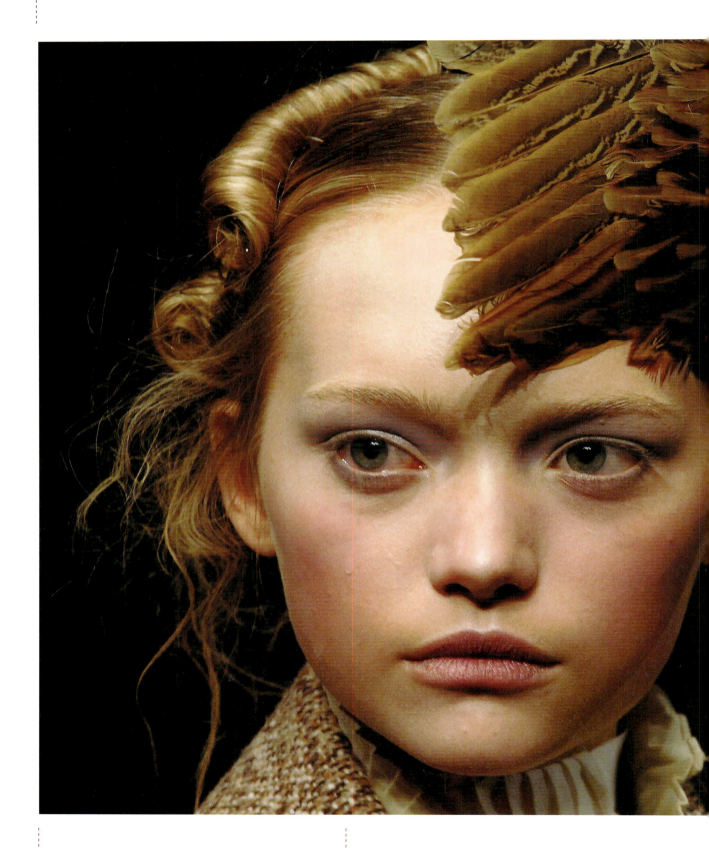

ABOVE: Autumn/Winter 2006 "The Widows of Culloden"

GLAMOUR AND PAIN 2006-2010

A selection of black garments began the show; the "feral" girl was still in her tree, wearing black, skinny trouser suits, elaborate leather biker-style jackets and even a wonderful, grey parachute dress. Then came a range of knitted mohair and corseted Victorian tops, which gave way to more black, this time lightened by glittering jewellery and lighter colours hinting at the sumptuousness to come.

Once the girl had descended to the ground, colour and opulence unfolded to her; peacock embroideries, velvet jackets and flat, bejewelled Indian-style shoes rubbed shoulders with regimental, braided dress coats that were followed by a reworked Union Jack dress with a cascading jewellery headpiece to underline the royal theme. The fabrics flowed in bright hues and either emphasised the excess of the ruling elite or were splayed outwards in white in the style of a ballerina's tutu, all the while encrusted with jewels as befitted a little girl's dream or an eastern princess. But a fabulous, bulleted, crimson coat topped the collection, the vividness of the silk's colour almost stinging the eyes of the onlookers.

Amongst an avalanche of plaudits from everyone, even the word *"perfection"* could be heard. McQueen had struck sartorial gold, for his company had, at last, become profitable.

Professional success did not impress the gods; they had decided not to release McQueen from emotional agony. Another of his beloved women, his mother, was also going through a menacing experience. Her son had expressed his fear of dying before her, the first woman to stay faithfully at his side in the face of the storms assaulting him. In 2004, he sat for an interview with his mother. She asked the question, *"What makes you proud?"* He replied, *"You"*. In 2008, Joyce was diagnosed with cancer and fear loomed up to haunt him. He was visiting a psychiatrist in an attempt to bring that fear and others down to manageable size.

Despite those fears, having proved that he could be successful

financially, too, seemed to free McQueen from hurling his neuroses undiluted onto the catwalk, and he turned to the natural world for his next theme, which was shown in front of a gigantic projected image of the earth. Stuffed wild animals populated the rear of the runway. McQueen cited Charles Darwin's 'Origin of the Species' as being the inspiration for this collection, together with concern for the destruction of the planet through industrialisation, ironically using that iconic piece of industrial hardware, the computer, to enhance and print designs on his clothes. After all the sartorial histrionics, this style became one of his lasting legacies to the fashion world; he was one of the first to employ the technique.

The show reunited many of the McQueen specifics such as strong shoulder lines, stiff mini-dresses, puffed hips and wasp waists as he worked his way through from the natural world in its untouched-by-man state to that most glamorous result of man's destruction of the earth, the diamond.

The first looks in "Natural Dis-Tinction, Un-Natural Selection" for spring-summer 2009, were in browns, muted reds, yellows and cream colours, with animal skin, flora/fauna patterning and leather bodices. Tendrils of hair were plastered vine-like to the models' faces. A shift in emphasis came with a shimmering fish-skin body suit with shoulders touching on the shape of the manta ray; its intricate prints in green and browns also resembled those of a magical forest creature. When more colour was introduced to the runway, it came in kaleidoscope patterns covering entire pieces dominated by blue, yellow or red, drawing comparisons with tropical bird life.

Vertebrae design printed jackets with matching printed leggings brought back the brown and cream colouring, which were the heralds of shining black fabrics, black leather and pieces adorned with thousands of glittering Swarovski crystals.

McQueen made an appearance as a giant rabbit. A slice of a lighter side of McQueen rarely seen in the past and at odds with the impending catastrophe.

The set for what transpired to be his penultimate show indicated, perhaps unintentionally, the state of play in the McQueen world, with his mother still suffering from cancer. It was a heap of mankind's junk; he intended the show to reflect the uncertainty and transience of the world and of the world of fashion in particular – the Lehman Brothers had just dramatically rammed home to everyone the consequences of man's selfish wastefulness and greed – so the autumn-winter 2009/10 collection was pointedly entitled "The Horn of Plenty", also the name of the pub which Mary Kelly visited before Jack the Ripper accosted her. This heap of industrial flotsam and jetsam placed on a 'shattered' glass runway to symbolise the fashion world's splintered, narcissistic lifestyle, also humorously reflected McQueen dipping into the bag of his own past in the collection and reworking what he found there; Givenchy, Dior, The Birds. Treacy excelled himself, and his hats were also ingenious representations of industrial debris.

Bold patterning took a variety of looks from other designers and enhanced them so they became something new and exciting. McQueen was parodying the design world – the models sported huge, bright red lips – at the same time as being part of it; a tricky tightrope act, as he knew.

Dior's houndstooth checks succoured the initial part of the show, a series of enlarged and occasionally stiff-collared versions of the classic twinsets, which were also subverted into clown-like costuming or appeared to have run loose in a sewing machine. The black section that followed was fractured by a splendid array of startling oranges, including a lavish evening gown, boldly patterned with white and black lines. There were Japanese undertones and McQueen's favoured fetish decorative elements also; leather straps and masks. *"I ... like the accessory for its sadomasochistic aspect"*, he is quoted as saying. Birds' feathers and bird prints introduced another of McQueen's favoured themes. Teetering

GLAMOUR AND PAIN 2006-2010

on enormous high-heeled platform shoes, two models were now encased in swan-like feathers from head to toe, one in innocent white, one in threatening black, making a no-compromise philosophical conclusion to the show.

For a man who loved the water – McQueen mentioned in an interview that he was happiest when scuba diving – it was surprising that he had not used it or the creatures of the sea as a theme to support one of his collections. He almost left it too late. When it did occur to him to do so, however, it drew from him one of the most splendid displays he ever made. He named it "Plato's Atlantis" and it was his spring-summer 2010 collection. It was dramatic for a variety of reasons. The show fed live to showstudio.com, the website belonging to Nick Knight, fashion photographer par excellence. Two cameras on robotic booms, running up and down tracks set into the sides of the catwalk, captured every move on the runway. The intention was for the world to watch it live, his unedited work viewed by the public in the same way that he saw and experienced it, without the filters and distortions of art critics, fashion magazines, or broadcasting technicians. Lady Gaga thwarted the intention by announcing her new single would be launched at the presentation, and the resultant online interest crashed the site.

The show opened to a darkened room. The accompanying sounds were an eerie blend of futuristic machinery noise, scuba diving respirators and ocean waves. The audience watched a video projection whose color range was restricted to blue, black and white. The huge video screen shone a naked Raquel Zimmermann, writhing on sand and dark blue water, onto the onlookers, with sinister erotic symbolism added in the form of similarly writhing snakes looping over her.

A rapid progression of images followed. Zimmermann's movements conjured up a pervasive sense of erotica, physical merging, metamorphosis, and rebirth. The choreographed interplay between the sensations of hard and soft, large and

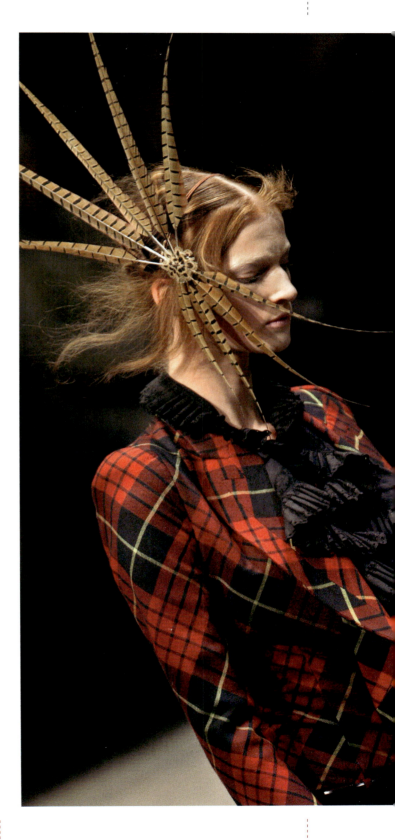

ABOVE: Autumn/Winter 2006 "The Widows of Culloden"

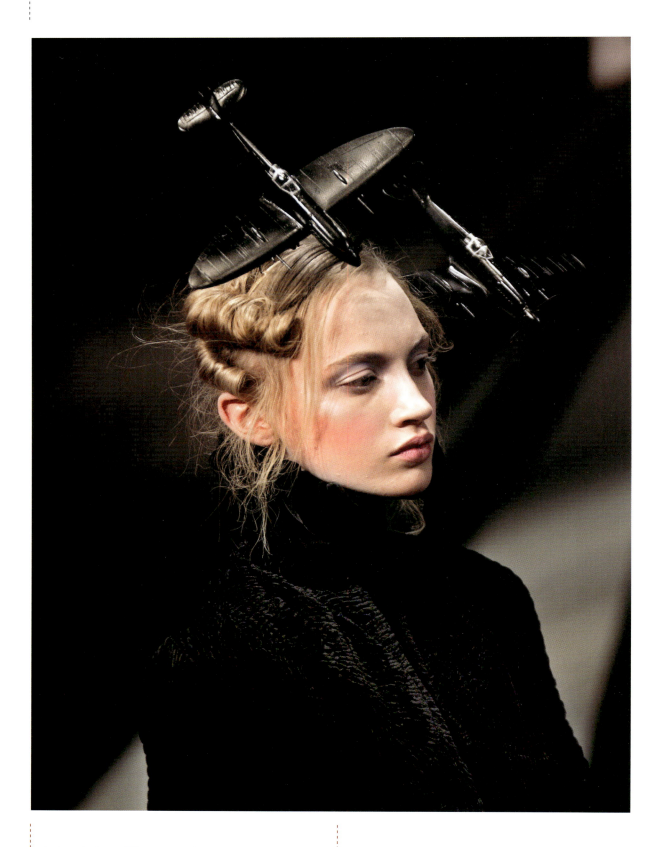

ABOVE: Autumn/Winter 2006 "The Widows of Culloden"

small, light and dark and ethereal and robotic was sublime. With the audience bemused and slightly alienated, the spell worked quickly. McQueen's vision juxtaposed a post-apocalyptic land, a sensuous primordial sea, and the mythical, other-worldly place that lies in between. He prolonged this sense of disorientation. In 'Plato's Atlantis' mankind was living in a new aquatic world and McQueen's clothes reflected the altered environment. The models' faces were made reptilian, lacking visible eyebrows, and their eyes were made up to seem elongated; hair was tightly formed into horn shapes with wisps. Even the infamous ankle-breaking 'Armadillo' 12-inch shoes were designed to represent a different human creature, adapted to live beneath the surface, having destroyed the land, with claws instead of feet.

Images of marine life were depicted in fabulous patterns; again the kaleidoscopic effect of digital printing was used to glorious effect, replicating reptilian skin and plants. The rigid skirts of previous collections had given way to fluidity and liquidity and green-blue-brown hues that reflected marine life and sunlight reflecting on and in water. There was looseness around arms and thighs, although the ultra mini, balloon dress with puffed shoulders and the indispensable leather straps did make it through to the gleaming new world.

One sumptuously coloured print followed another as the greens yielded to saturated blues. Amongst this flowing softness, the 'Jellyfish' dress presented a vivid contrast; a shell of shining enamel paillettes that ran over the dress, tights and shoes. It was McQueen's glowing swan song.

Whilst Lee McQueen worked on his collection for the autumn 2010 show he had been suffering badly. In fact, he was suffering so badly that in 2009 he had attempted suicide twice. One of his problems was love. Apparently, McQueen had been seeing a porn star. In September 2009 he was interviewed by the New York Times Magazine and talked about a *"Mr. Stag"* whom he met on an internet site. Was this *"Mr. Stag"*, Aiden Shaw, a 43-year-old escort? Some sources believed so and later, Shaw mentioned a ring that the designer had supposedly given to him. The relationship had failed. In another interview, McQueen did not identify *"A bastard who went back to Australia, and I was left looking at his name."* McQueen had been strongly attached to the Australian and had even tattooed the man's name on his arm.

Then tragedy struck him a second time. His mother had been in hospital in the terminal stages of cancer. In his own state of turmoil, Lee had found it unbearably hard and had to be persuaded to visit her. On February the 2nd 2010, aged 75, his mother died from cancer. The rock, as he called her, that had supported him unflinchingly, was gone.

McQueen was not only devastated, he was a man cut adrift. Life had become a continual merry-go-round of pressures. There were six shows each year to contend with and on top of those, his own collections. The release of stress following a show left him feeling bereft and alone, and in the vacuum, he went down to his personal depths. According to his psychiatrist, the last three years of his life had been extremely difficult for McQueen. He suffered under the pressure to perform, to be better than the sixty other top designers showing just in London, but also from the sense that outside of his work, which he felt was where he had done something of value, in his personal life he had not progressed. He no longer embraced the glitzy life, preferring to spend his free time by himself, skiing, or quietly with his dogs. Although now and again he was seen on the slopes with best pal and muse Annabelle Neilson, a socialite and wild-child famous for riding a motorbike across Australia.

Dr. Pereira, McQueen's psychiatrist mentioned that, *"He had been let down by his friends, who he felt were taking advantage of who he was. For that reason he was very guarded with most people."*

There had been previous suicide attempts and substance

abuse. The two 'cry for help' attempts to kill himself had taken place in May and July of the previous year; McQueen had taken drug overdoses and been referred to a psychiatrist.

Now, his beloved mother Joyce had left him alone. All that he had achieved, he had done for her. Without her, he was overwhelmed with grief, loneliness and despair; he felt unable to face a future that was empty of meaning. The failed romance and a surge in drug use had played their vicious part in his depressions; certainly, too, for the sensitive and family-loving Lee, had the death of his aunt Dolly the year before, a woman who had attended all of his shows.

Nine days after his mother's death and the day before her funeral, Lee was in his two million pound Mayfair apartment having taken to his bed. Apparently, he did an internet search on his laptop on how long it takes to die once a person slits their wrists. This time he was not going to take a chance. He took cocaine, so much that he could have died multiple times from that alone. 2.8 milligrams of cocaine per litre of blood were later discovered by toxicologists; 0.7 milligrams can prove fatal. He followed cocaine with some sleeping pills. Then, according to one source, he went into the shower with his dressing gown cord and tried to hang himself. When that proved ineffective, he must have taken a selection of knives, and gone into his closet. With his favourite brown belt around his neck, Lee then slit his wrists, and hanged himself. His lifeless body was discovered by the maid.

There was a suicide note, the details of which have mostly not been made public, except for the words: *"Please look after my dogs. Sorry, I Love you. Lee. P.S. Bury me at the church."* Lee Alexander McQueen's agony was at an end.

The coroner's verdict was suicide *"while the balance of his mind was disturbed"*, which is a mild version of what had been happening to one of the best British designers of his generation.

George Forsyth, McQueen's former partner who was 22 when they met, confessed that he was baffled by the death and had not expected it. Lee, he had thought, was strong enough to have coped with the difficulties he was experiencing. Yet, through George's words, we are confronted with the image of a lonely man amidst the glamour and shallowness of the fashion world. The image of a man whose public persona was at odds with the man his friends knew and loved. The private, sensitive Lee indulged in a life that was guaranteed to bring him into conflict with himself. *"We went to all these mad parties. There were parties every night. There would be ice sculptures and expensive champagne and people jumping into swimming pools fully dressed, and drugs"*, said George. Many old friends had been sidelined.

But now the show was over, and the lights went out on the magical runway that had thrilled fashionistas and brought a fresh, exotic, if fractured and flawed spirit into fashion design.

GLAMOUR AND PAIN 2006-2010

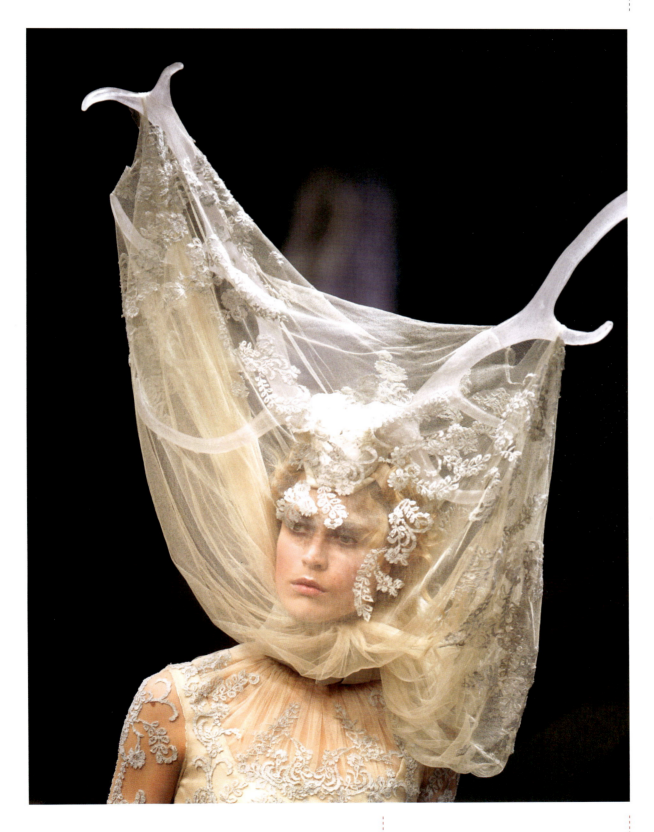

ABOVE AND LEFT: Autumn/Winter 2006
"The Widows of Culloden"

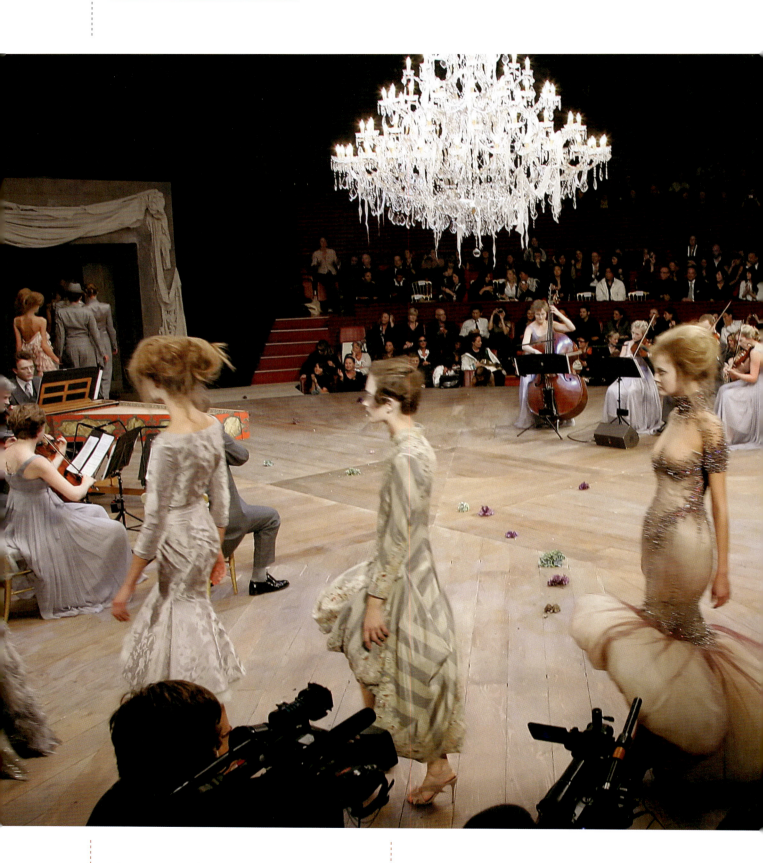

ABOVE AND RIGHT: Spring/Summer 2007 "Sarabande"

GLAMOUR AND PAIN 2006-2010

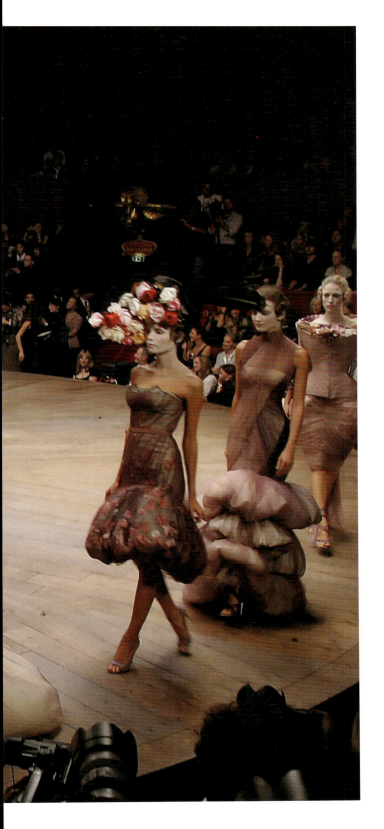

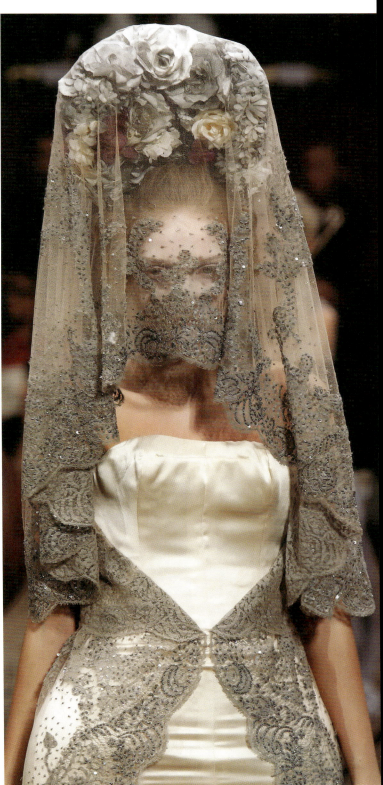

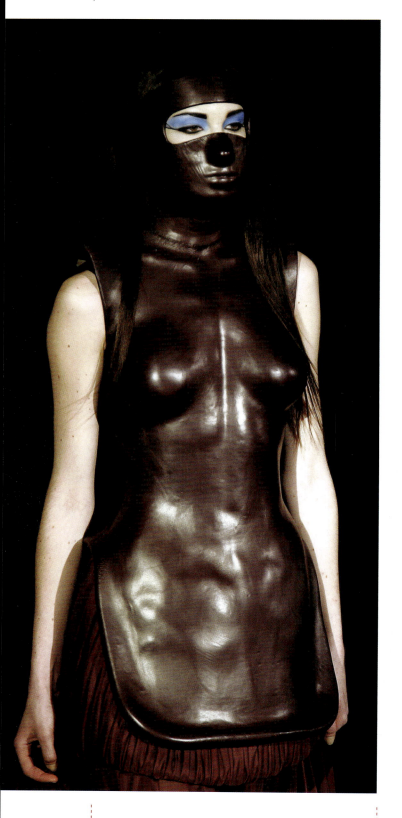
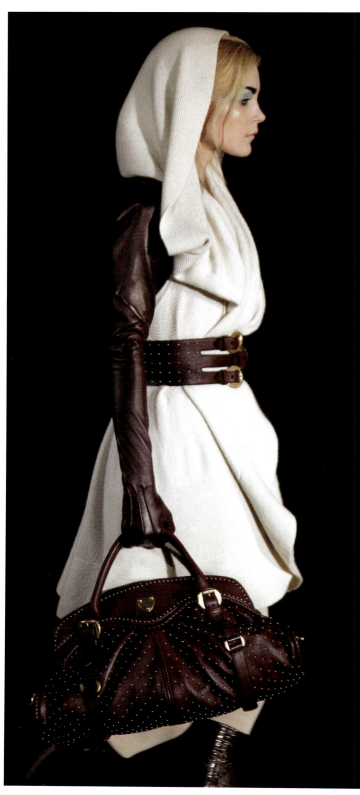

ABOVE AND RIGHT: Autumn/Winter 2007
"In Memory of Elizabeth Howe, Salem, 1692"

GLAMOUR AND PAIN 2006-2010

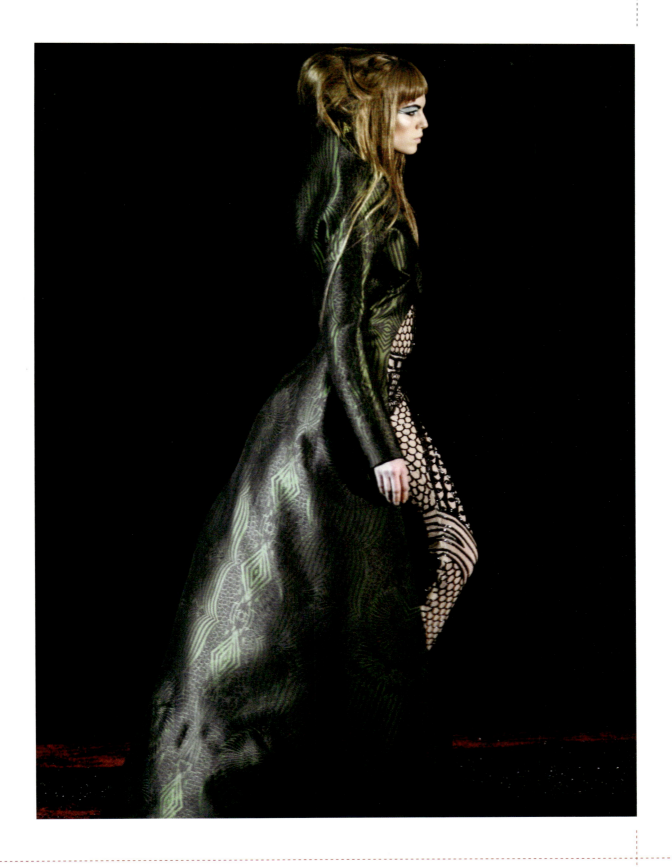

THE FASHION ICONS McQUEEN

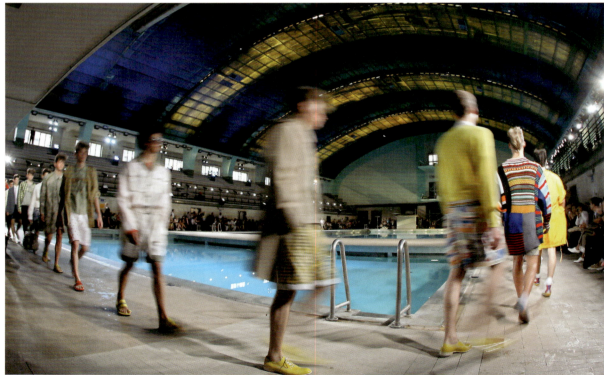

ABOVE AND RIGHT: Menswear Spring/Summer 2008 "Please, Sur"

GLAMOUR AND PAIN 2006-2010

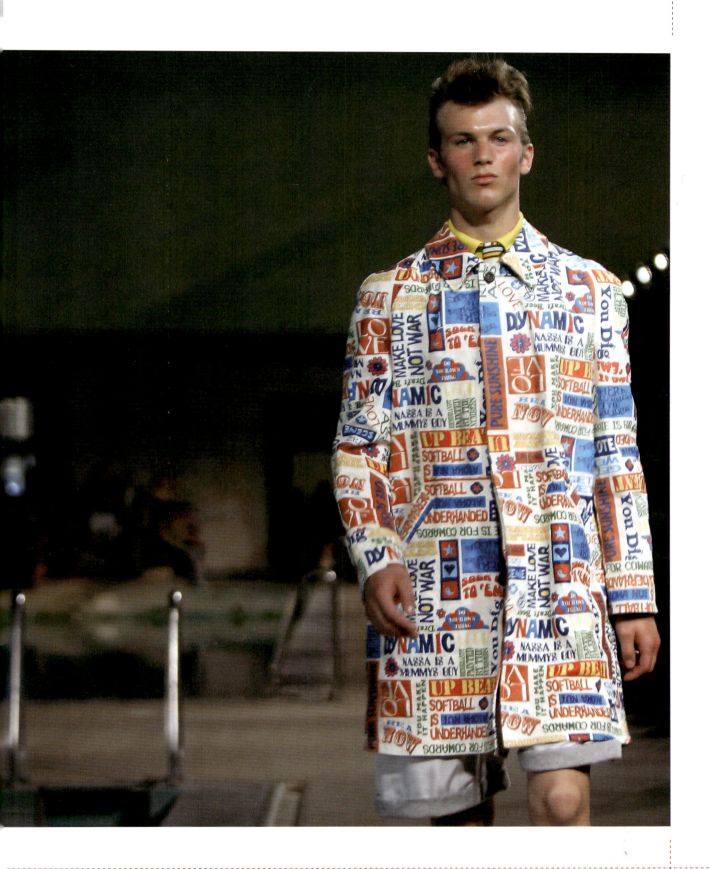

THE FASHION ICONS | McQUEEN

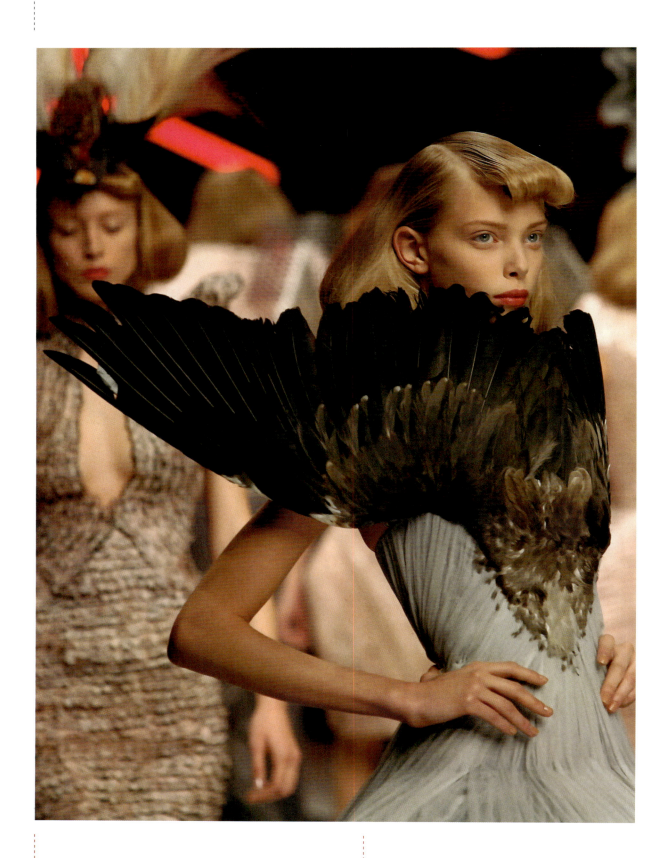

ABOVE AND RIGHT: Spring/Summer 2008 "La Dame Bleue"

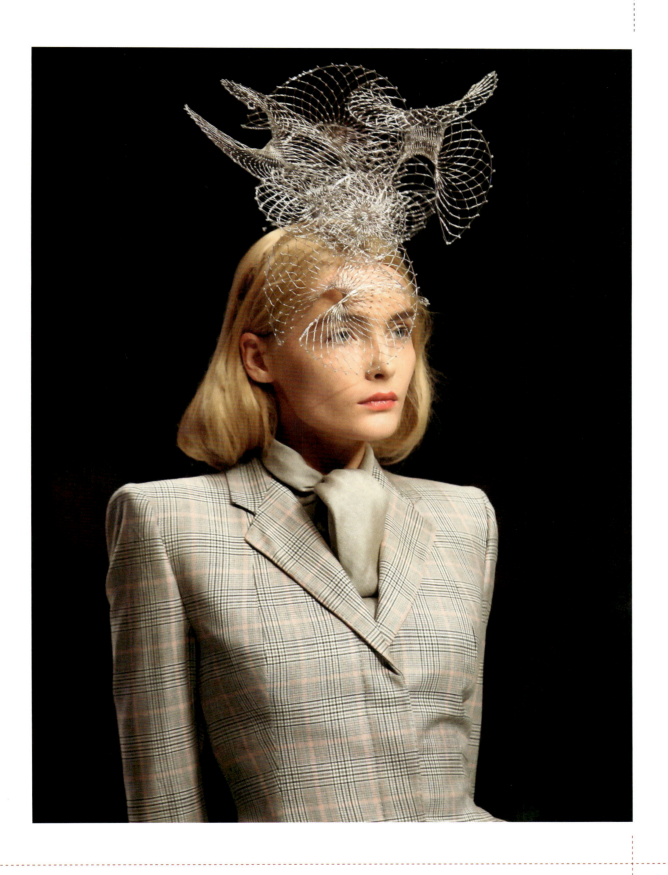

ABOVE AND RIGHT: Menswear Autumn/Winter 2008 "Pilgrim"

GLAMOUR AND PAIN 2006-2010

118 THE FASHION ICONS McQUEEN

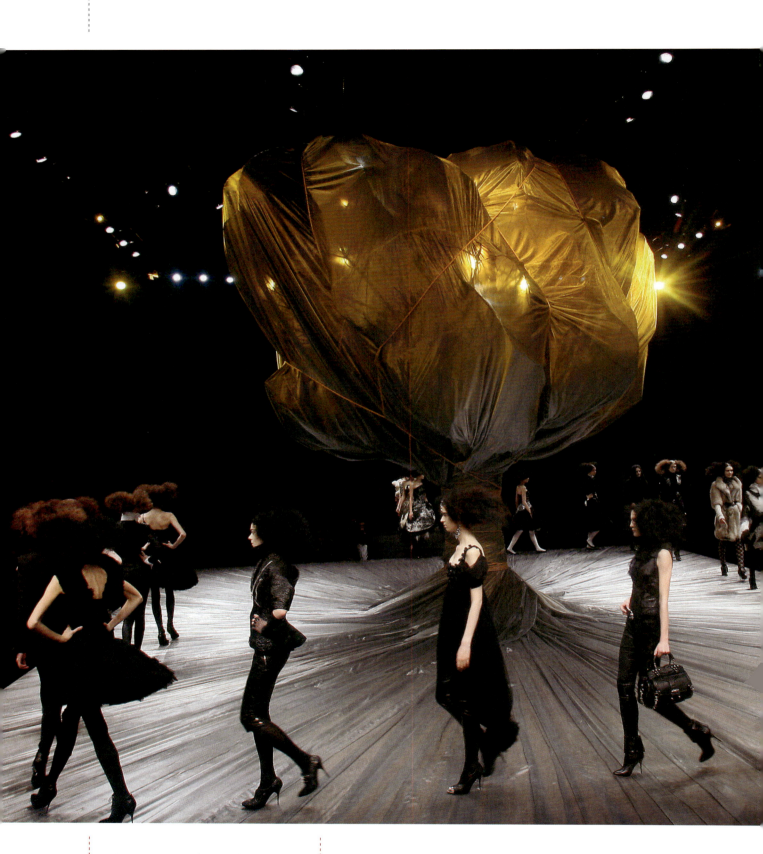

ABOVE AND RIGHT: Autumn/Winter 2008
"The Girl Who Lived in the Tree"

GLAMOUR AND PAIN 2006-2010

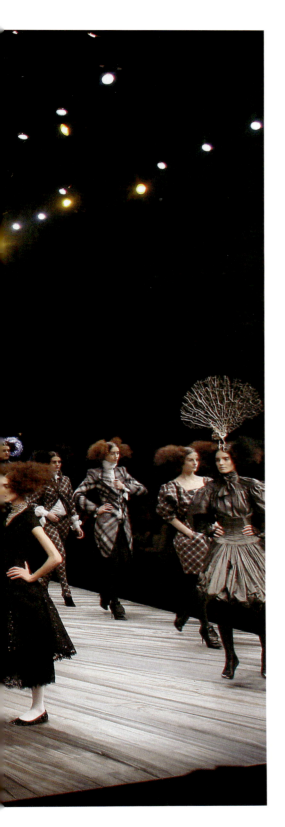
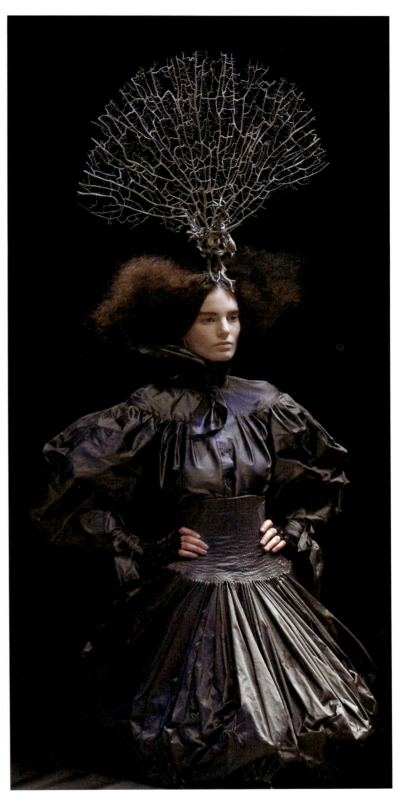

THE FASHION ICONS McQUEEN

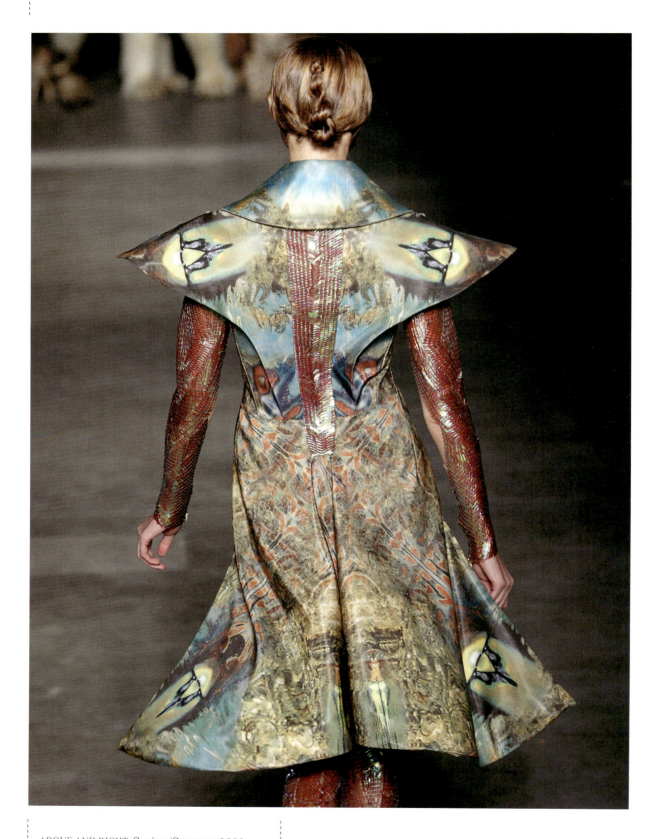

ABOVE AND RIGHT: Spring/Summer 2009
"Natural Dis-tinction Un-Natural Selection"

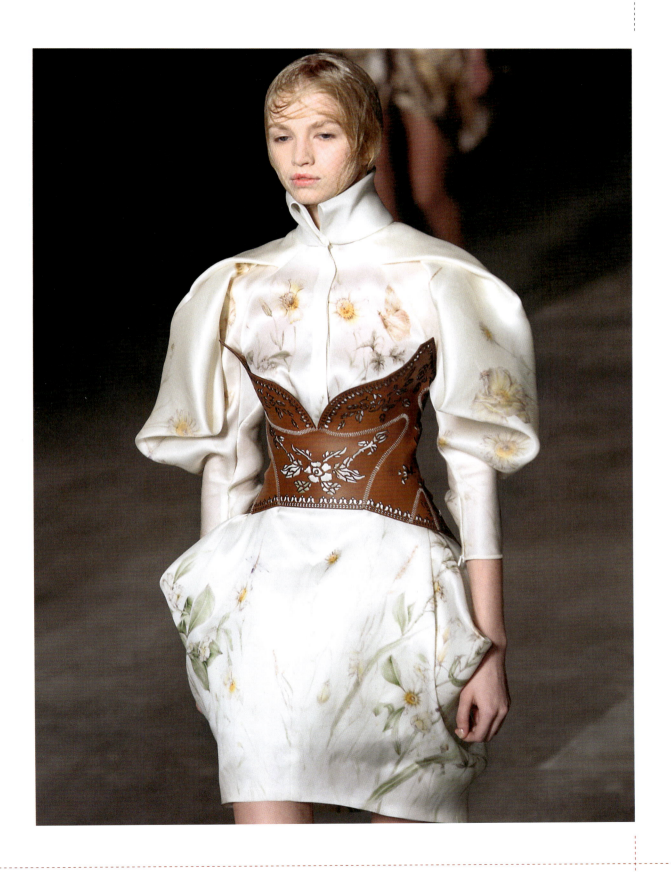

THE FASHION ICONS McQUEEN

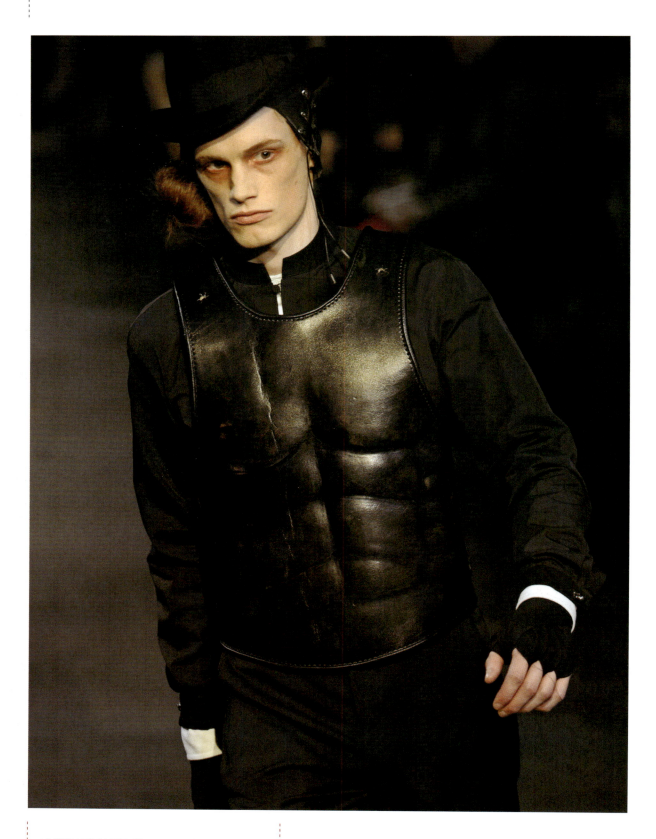

ABOVE AND RIGHT: Menswear Autumn/Winter 2009 "The McQueensbury Rules"

GLAMOUR AND PAIN 2006-2010

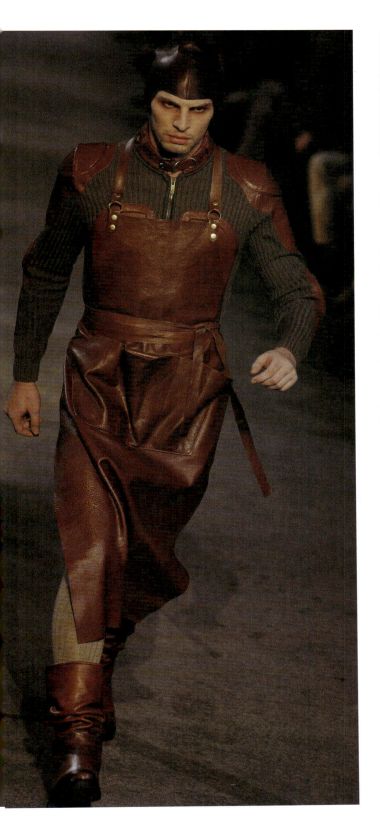
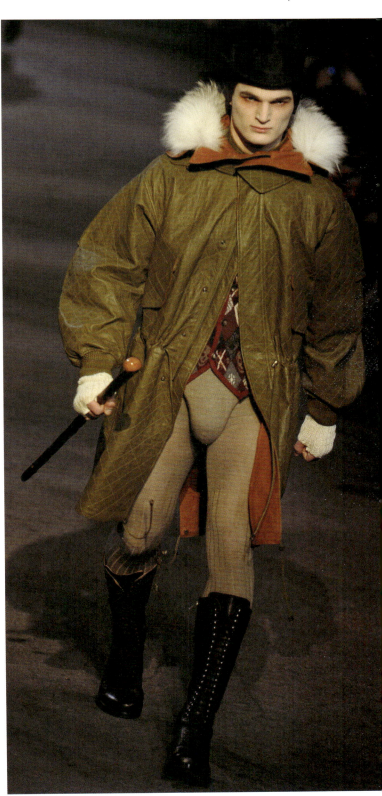

THE FASHION ICONS McQUEEN

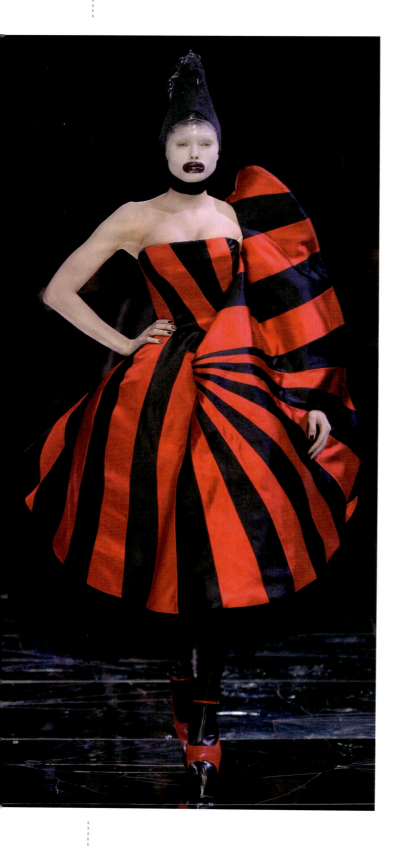
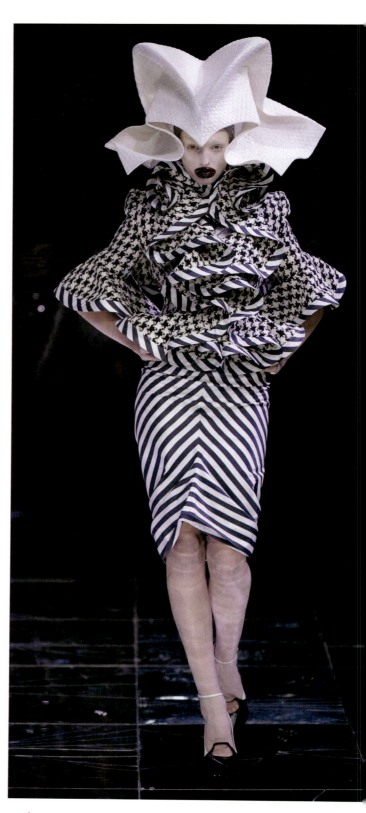

ABOVE AND RIGHT: Autumn/Winter 2009 "The Horn of Plenty"

GLAMOUR AND PAIN 2006-2010

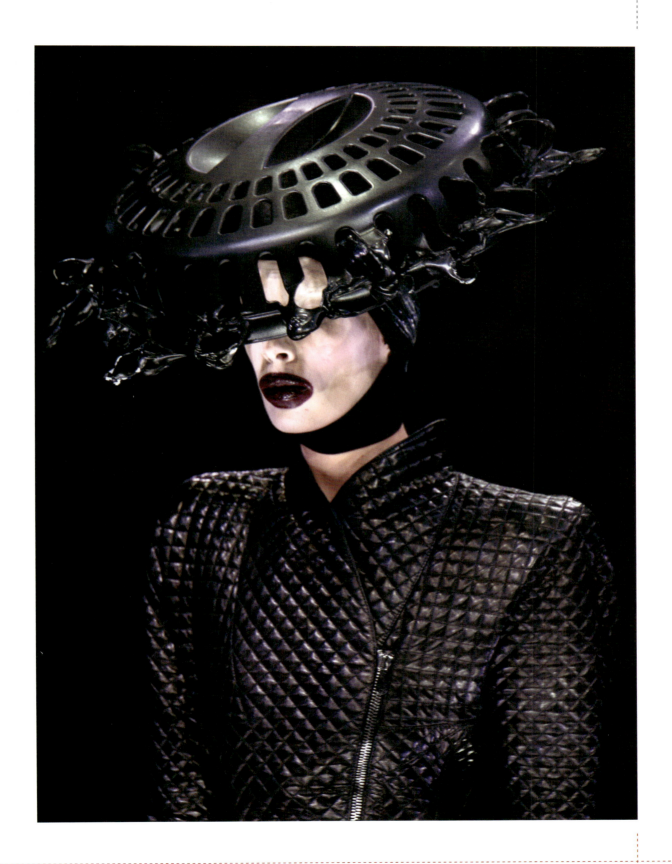

THE FASHION ICONS McQUEEN

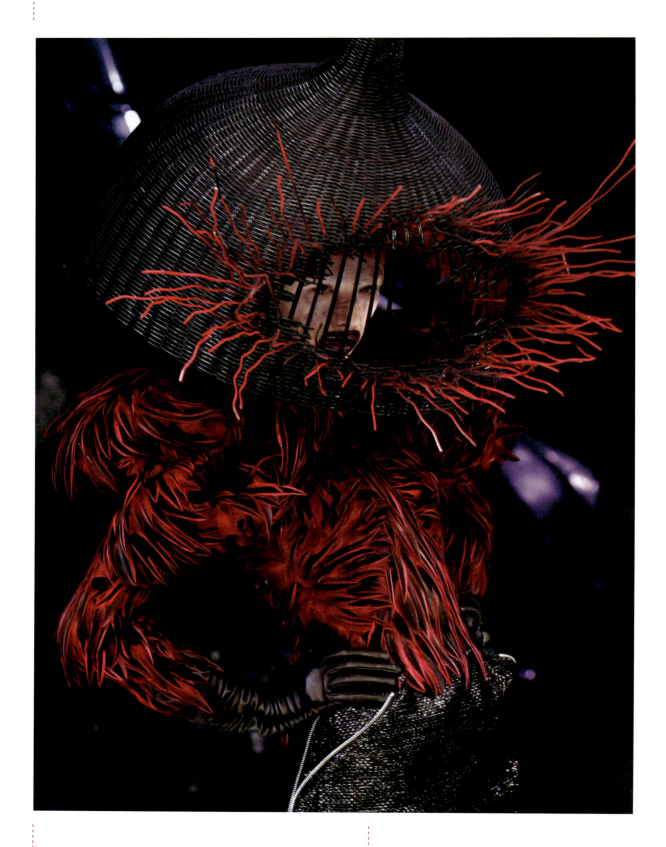

ABOVE AND RIGHT: Autumn/Winter 2009 "The Horn of Plenty"

GLAMOUR AND PAIN 2006-2010

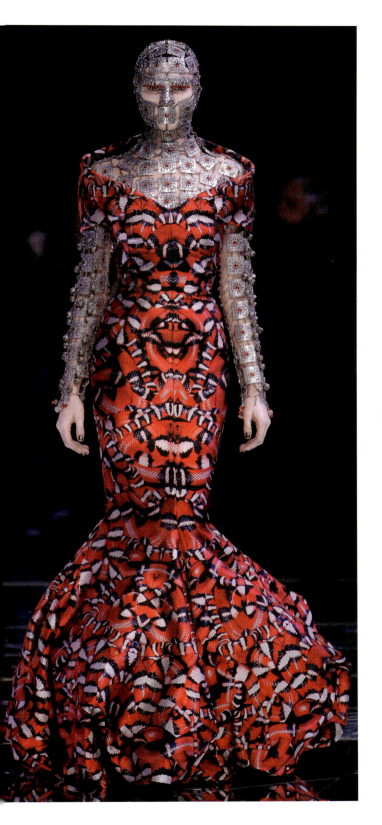
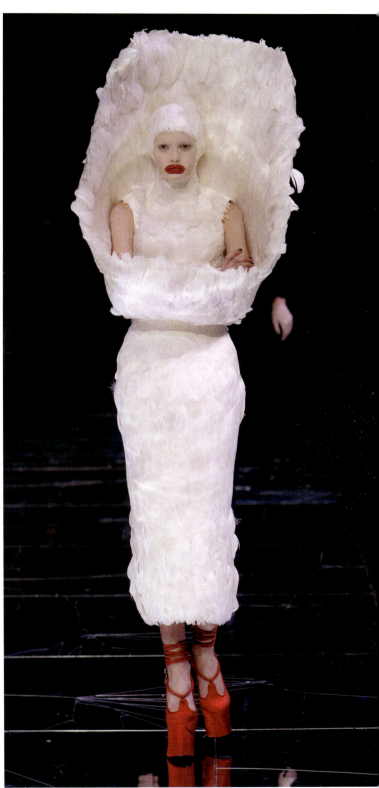

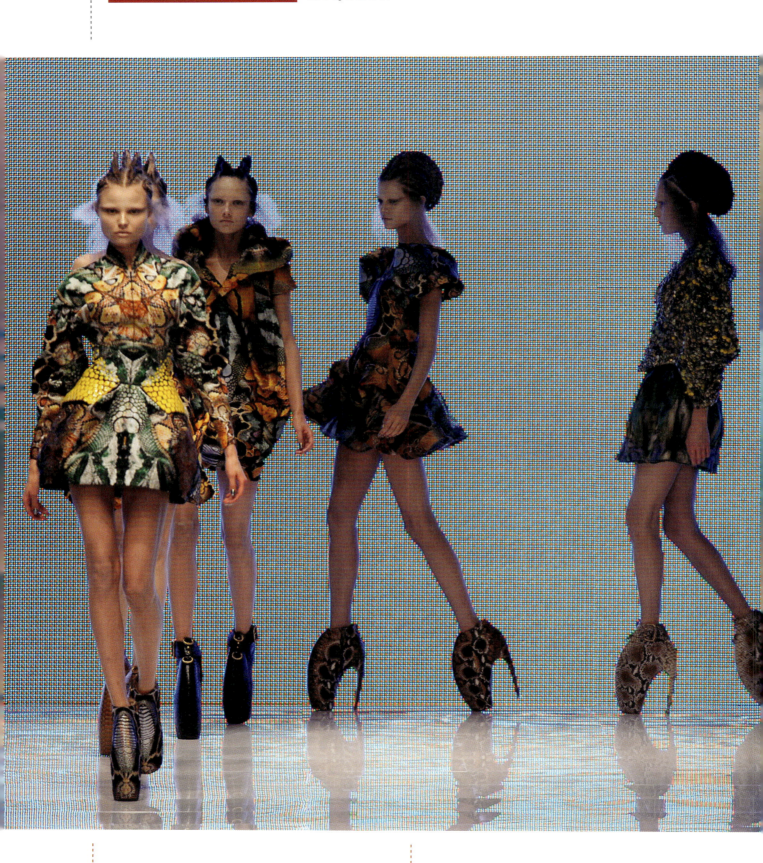

ABOVE AND RIGHT: Spring/Summer 2010 "Plato's Atlantis"

GLAMOUR AND PAIN 2006-2010

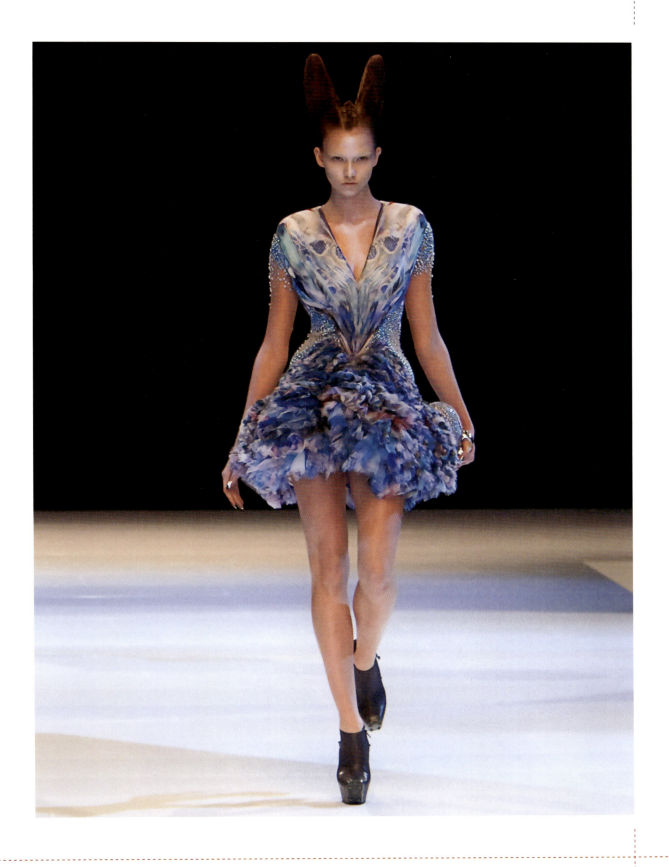

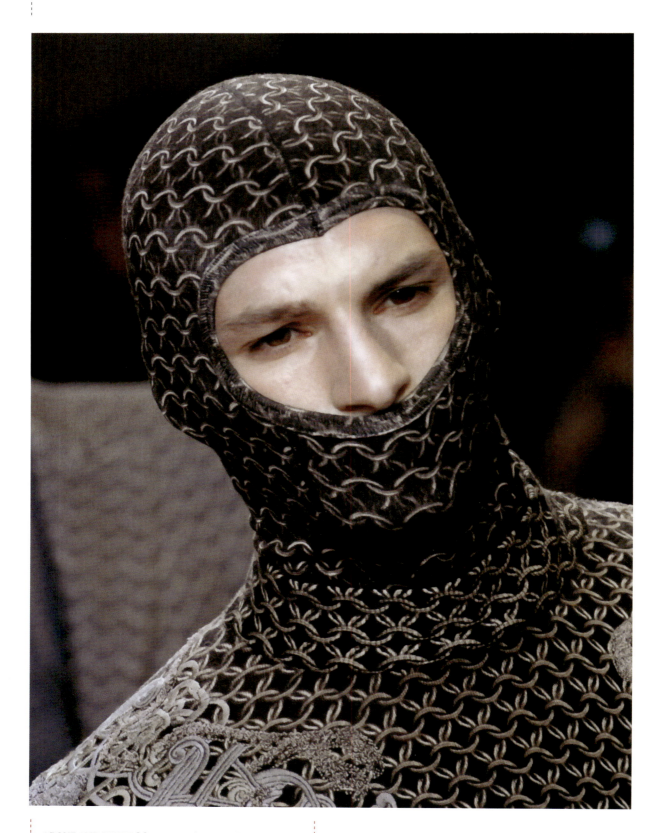

ABOVE AND RIGHT: Menswear Autumn/Winter 2010
"An Bailitheor Cnámh"

GLAMOUR AND PAIN 2006-2010

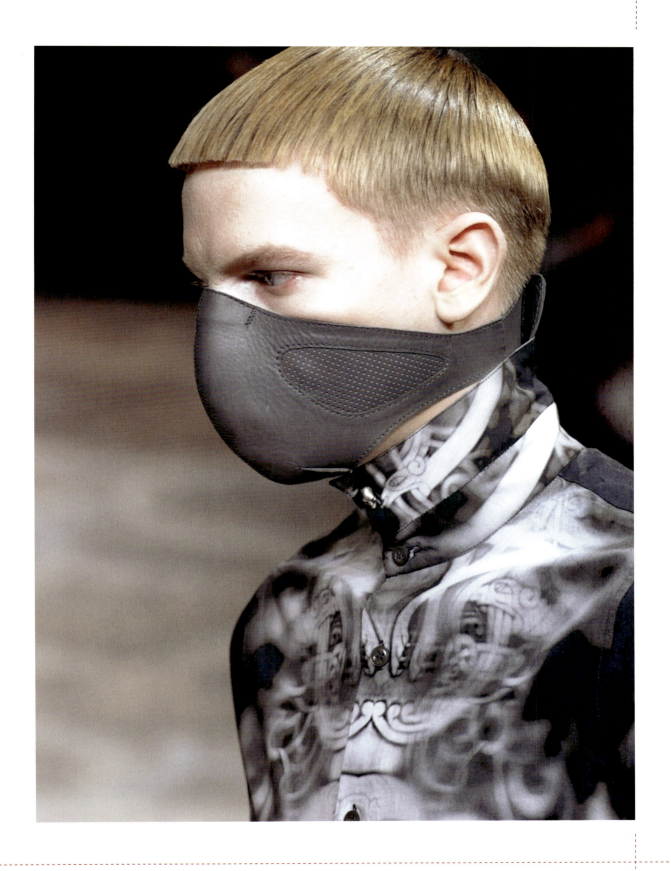

THE FASHION ICONS | McQUEEN

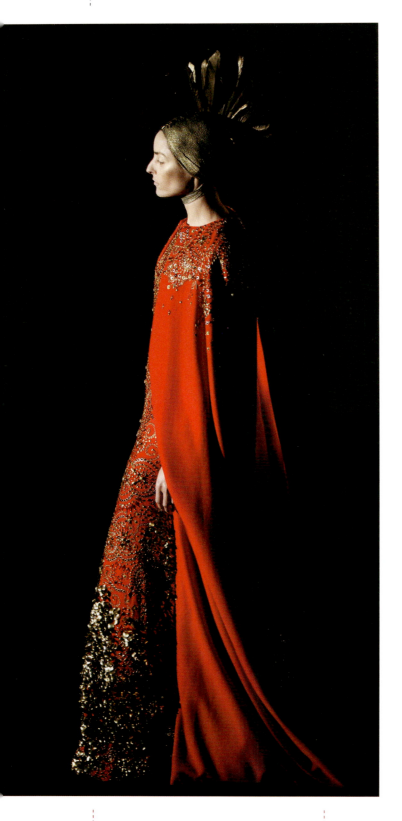
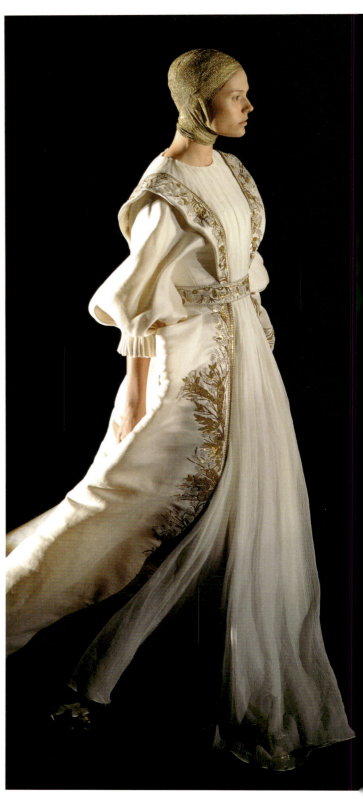

ABOVE AND RIGHT: Autumn/Winter 2010 "Angels & Demons" (Unofficially titled)

GLAMOUR AND PAIN 2006-2010

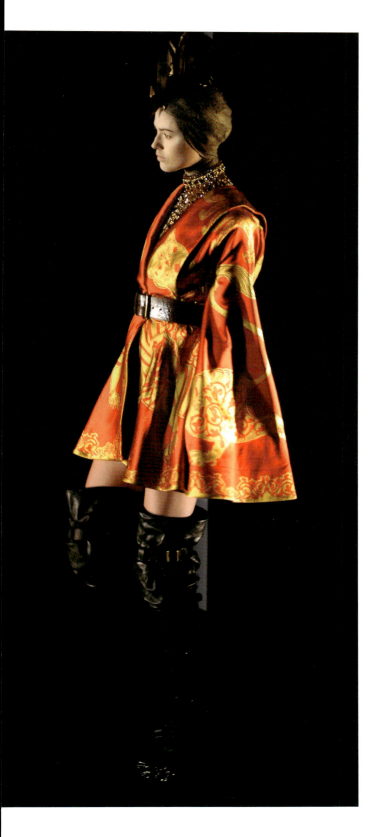
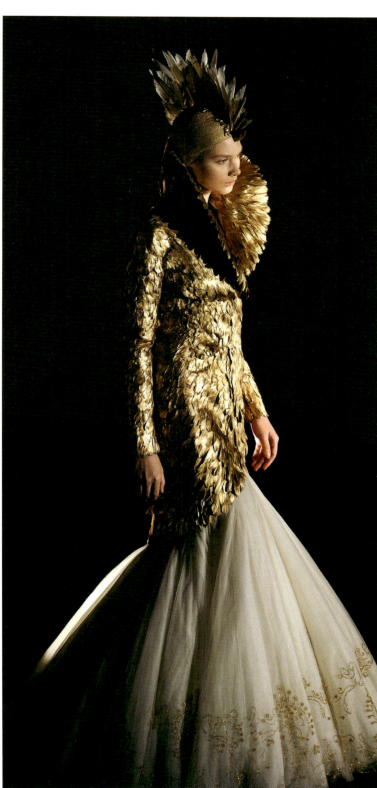

THE LEGACY

"When I'm dead and gone, people will know that the twenty-first century was started by Alexander McQueen."

Lee Alexander McQueen left one immediate legacy; at the time of his death, he had been working on his next collection and sixteen of the pieces were almost ready; just the final 20% of the work was still to be done. It was decided that they should be completed and form an autumn-winter 2010 collection, unofficially named 'Angels and Demons'. Sarah Burton had been McQueen's 'third hand' for ten years – and therefore steeped in the dyes of his ethical and artistic visions – and it was now left to her to complete the visual concepts McQueen had begun.

The collection, shown in Paris on March the 9th and 10th 2010 to a succession of small groups, leant heavily on the great medieval master artists; Sandro Botticelli, Jean Fouquet or Hieronymus Bosch, and the baroque era and its extravagant ornamentation, represented by Grinling Gibbons. Inspiration from the Byzantine era was evident in rich embroidery and jewellery. Digital printing featured strongly, proving that Lee had not abandoned technology entirely following the internet streaming debacle, with heavy silks in saturated reds as the medium, the heaviness emphasising the sinister underbellies inherent in the nature of the eras which the clothes referenced.

There was no fantastical presentation, no mythical darkness or strobing light show; the clothes were presented to classical music and without fuss or lurid makeup, in a rococo era private house. It was a rather strange atmosphere for Lee's creations; bright and airy, in which the clothes seemed as vulnerable as their creator had been. It was more of an obituary than a presentation.

The designer's vision was as unique as ever; a gold-painted, duck feather coat with a signature high collar, enclosing a white silk tulle dress dusted with golden embroidery that funnelled to the floor; a thigh-length brocaded jacket in scarlet silk with black boots to mid thigh; printed silk adorned with images from the old masters. Another piece in scarlet was a gilded brocade bodice atop a pleated mini-skirt that seemed to hang independently from the model. The models' heads were bound with bandages in imitation of the head coverings prevalent in the Northern Europe of the 1600s and also a reminder of his 'Asylum' collection in 2001.

Hieronymus Bosch would have inevitably featured in a McQueen show; the sinister ugliness the painter portrayed expressed what the designer saw in his own world. As a print, Bosch's visions of hell found their way onto a long-sleeved bodice and pleated black mini.

A third garment in scarlet red, a highlight of the 16 pieces, was an exquisite red gown, heavy with gold decoration boasting true Byzantine excess, beneath a full-length red cape, hand embroidered; both very simple cuts beautifully rendered.

In simple, virginal white, an almost angel-like, religious image, McQueen presented a long gown, silver embroidered this time, with a modestly high neckline.

It was a toned-down Lee McQueen. Whether it accorded to his vision we shall never know, nor what other delights he had planned for the show but not expressed to his team, but it was decidedly less expansive than his other collections.

Sarah Burton was another of Lee's legacies to the fashion world. Simon Ungless, who is director of the School of Fashion at the Academy of Art University in San Francisco, was one of Lee's closet friends and introduced the young Burton to McQueen. She joined McQueen as an intern in 1996. Her gentleness, her love of art, history, film and the craft in their work engendered the loyalty that McQueen could give but also demanded of those around him. He was very wary of people and they were tested by McQueen to see if they would stay the course. Burton did and was at his side for the next ten years, their symbiosis producing the forward-driving clothing that shook up the fashion world. According to McQueen she had the DNA to work the way he did and felt the collections would be safe in her hands. As Simon Ungless said, "He just absolutely adored her". Whatever happens to the talented Sarah Burton after McQueen, she will doubtless feel McQueen's spirit alongside her as she pursues her own visions, just as her mentor did.

It was McQueen's wish to support British designers who might not have the financial means to pursue their studies in fashion design. School fees are often huge and talent can be crushed by them at the starting line. So McQueen set up a trust fund known as 'Sarabande' to at least partially fund their studies and keep British design alive and kicking as he would have wanted it to be. If the new generations of designers emerge fighting and saying "Fuck French fashion!" as he once did, then he would doubtless have been doubly happy.

Alexander McQueen's greatest legacy is without doubt the memory of Lee Alexander McQueen himself, what he achieved and how he brought about his vision of fashion as art and as an expression of contemporary thought. In McQueen's hands, fabrics transmogrified to become manifestations of the human condition and mirrors detailing humanity's fears and delights, secret or otherwise. His trajectory from street kid with flailing arms to fashion icon steeped in the history of culture is his personal legacy, left to us all. His fight against his own demons and the rigid snobbery of the fashion world whilst at the same time producing some of the most original and sumptuous pieces of work will always be a source of inspiration.

As for those who were closest to him, and there were many who mistakenly assumed they were, George Forsyth, spoke for them; " ...that's the real loss and the real waste. It's not that he made women look great, it's that he was a beautiful bloke, a really beautiful person with a big heart."

Lee Alexander McQueen chose Kilmuir in Scotland as the place to have his ashes buried. He remained at heart what he had always been and refreshingly down to earth.

THE RUNWAY COLLECTIONS

WOMENSWEAR

1992 Graduation Collection – Jack The Ripper Stalks His Victims

Autumn/Winter 1993 – Taxi Driver

Spring/Summer 1994 – Nihilism

Autumn/Winter 1994 – Banshee

Spring/Summer 1995 – The Birds

Autumn/Winter 1995 – Highland Rape

Spring/Summer 1996 – The Hunger

Autumn/Winter 1996 – Dante

Spring/Summer 1997 – Bellmer la Poupée

Spring/Summer 1997 – (The collection's theme was Jason and the Argonauts)

Autumn/Winter 1997 – Eclect Dissect

Autumn/Winter 1997 – It's a Jungle out There

Spring/Summer 1998 – Untitled (Originally The Golden Shower)

Autumn/Winter 1998 – Joan

Spring/summer 1999 – No. 13

Autumn/Winter 1999 – The Overlook

Spring/Summer 2000 – Eye

Autumn/Winter 2000 – Eshu

Spring/Summer 2001 – Voss

Autumn/Winter 2001 – What A Merry-Go-Round

Spring/Summer 2002 – The Dance of The Twisted Bull

Autumn/Winter 2002 – Supercalifragilisticexpialidocious

Spring/Summer 2003 – Irere

Autumn/Winter 2003 – Scanners

Spring/Summer 2004 – Deliverance

Autumn/Winter 2004 – Pantheon ad Lecum

Spring/Summer 2005 – It's Only a Game

Autumn/Winter 2005 – The Man Who Knew Too Much

Spring/Summer 2006 – Neptune

Autumn/Winter 2006 – The Widows of Culloden

Spring/Summer 2007 – Sarabande

Autumn/Winter 2007 – In Memory of Elizabeth Howe, Salem, 1692

Spring/Summer 2008 – La Dame Bleue

Autumn/Winter 2008 – The Girl Who Lived in the Tree

Spring/Summer 2009 – Natural Dis-tinction Un-Natural Selection

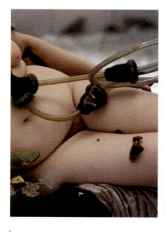

THE RUNWAY COLLECTIONS

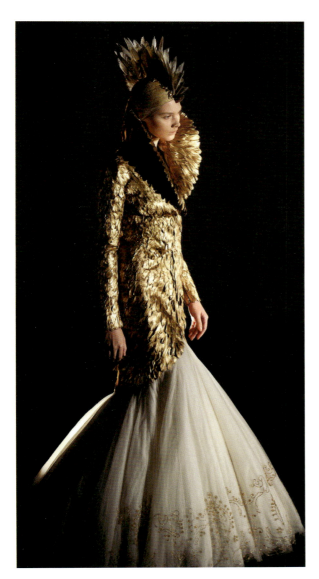

Autumn/Winter 2009 – The Horn of Plenty
Spring/Summer 2010 – Plato's Atlantis
Autumn/Winter 2010 – Angels & Demons
(Unofficially titled)

MENSWEAR

Autumn/Winter 2004 – Textist
Spring/Summer 2005 – Untitled
Autumn/Winter 2005 – Untitled
Spring/Summer 2006 – Killa
Autumn/Winter 2006 – Untitled
Spring/Summer 2007 – Harlem
Autumn/Winter 2007 – The Forgotten
Spring/Summer 2008 – Please, Sur
Autumn/Winter 2008 – Pilgrim
Spring/Summer 2009 – Love You
Autumn/Winter 2009 – The McQueensbury Rules
Spring/Summer 2010 – An Alexander Film Directed by David Sims
Autumn/Winter 2010 – An Bailitheor Cnámh
Spring/Summer 2011 – Pomp and Circumstance
Autumn/Winter 2011 – Untitled
Spring/Summer 2012 – Untitled
Autumn/Winter 2012 – Untitled

ALEXANDER MCQUEEN QUOTES

"My collections have always been autobiographical, a lot to do with my own sexuality and coming to terms with the person I am – it was like exorcising my ghosts in the collection. They were about my childhood, the way I think about life and the way I was brought up to think about life."

"There is no better designer than nature."

"Anger in my work reflected angst in my personal life."

"My influence comes through things that I see, from a tramp on the street to drugs in the clubs … it is just a part of my life…"

"I'm a romantic schizophrenic."

"I didn't plan out my life… When people recognize and respect what you do, that's nice."

"I find beauty in the grotesque, like most artists."

"I came to terms with not fitting in a long time ago. I never really fitted in. I don't want to fit in. And now people are buying into that."

"It's a new era in fashion – there are no rules. It's all about the individual and personal style, wearing high-end, low-end, classic labels, and up-and-coming designers all together."

"What we do have in London is a fantastic pool of talent coming through the colleges. We are the fashion world's incubator."

"Fashion should be a form of escapism, and not a form of imprisonment."

"When you see a woman wearing McQueen, there's a certain hardness to the clothes that makes her look powerful. It kind of fends people off. You have to have a lot of balls to talk to a woman wearing my clothes."

"You've got to know the rules to break them. That's what I'm here for, to demolish the rules but to keep the tradition."

ALEXANDER MCQUEEN QUOTES

"My work is about taking elements of traditional embroidery, filigree and craftsmanship from countries all over the world. I will explore their crafts, patterns and materials and interpret them in my own way."

"I never look at other people's work. My mind has to be completely focused on my own illusions."

"Fashion can be really racist, looking at clothes of other cultures as costumes …"

"You can hide so much behind theatrics, and I don't need to do that any more."

"There is a hidden agenda in the fragility of romance."

"I just want to be a wallflower. Nondescript. Just not anything. I don't want to see me."

"I want to be the purveyor of a certain silhouette or a way of cutting, so that when I'm dead and gone people will know that the twenty-first century was started by Alexander McQueen."

"For people who know McQueen, there is always an underlying message. It's usually only the intellectual ones who understand what's going on in what I do."

"There is something sinister, something quite biographical about what I do – but that part is for me. It's my personal business. I think there is a lot of romance, melancholy. There's a sadness to it, but there's romance in sadness."

WHAT OTHERS THOUGHT

"I feel his head was turned by fame but in the end he realised it was rather false and not all it was cracked up to be."

MICHAEL MCQUEEN (BROTHER)

"Alexander McQueen doggedly promoted freedom of thought and expression and championed the authority of the imagination. In this, he was an exemplar of the romantic individual, the hero artist who staunchly followed the dictates of his inspiration."

ANDREW BURTON

"Out of his despair came flights of beauty, images and ideas simply beyond the capability of most other designers of his generation."

JUDITH WATT

"Lee actually managed to transform bodies through clothing. He was the only one who was actually moving things forward."

DAPHNE GUINNESS

"I found his work very interesting and never banal. There was always some attraction to death, his designs were sometimes dehumanized. Who knows, perhaps after flirting with death too often, death attracts you."

KARL LAGERFELD

"I really don't know why he would do such a thing. It goes to show that money doesn't buy you everything. He was probably very lonely in his own way."

MICHAEL MCQUEEN (BROTHER)

"At one level, he was a master of the fantastic, creating astounding fashion shows that mixed design, technology and performance, and on another he was a modern-day genius."

ALEXANDRA SHULMAN

WHAT OTHERS THOUGHT

"I understood. That loneliness, that pain ... we're setting that bar impossibly high, we don't understand how we're doing it and people say, 'Wow, how are you going to top that?' And we're like, 'Well yeah we're going to, don't worry.' That's what makes us wake up in the morning. I was very sad."

JOHN GALLIANO

"He was a master of fashion, creative genius and an inspiration."

VICTORIA BECKHAM

"Alexander had blood running through his veins ... he was a real human being who hadn't lost himself completely in this world of appearances and complete and utter superficiality and business."

DAVID LACHAPELLE

"... if you had written him as a character in a novel, the end would almost inevitably have been the same. He came to a dinner with me a few weeks before he died. He looked so sharp and fantastic. I loved him and he's a true, true artist."

TOM FORD